D0902653

IMAGES
of America

OLD FORGE AND THE FULTON CHAIN OF LAKES

IMAGES
of America

OLD FORGE AND THE FULTON CHAIN OF LAKES

Linda Cohen and Peg Masters

linda cohen
Peg Masters
SARAH COHEN

ARCADIA
PUBLISHING

Published by Arcadia Publishing
Charleston, South Carolina

Printed in the United States of America

Library of Congress Control Number: 2010922404

For all general information, please contact Arcadia Publishing:
Telephone 843-853-2070
Fax 843-853-0044
E-mail sales@arcadiapublishing.com
For customer service and orders:
Toll-Free 1-888-313-2665

Visit us on the Internet at www.arcadiapublishing.com

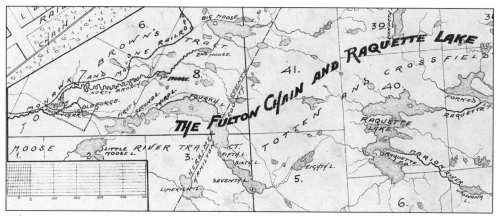

When researching historic places, maps are an invaluable tool. This small section of an early map of the region shows Old Forge at the foot of the Fulton Chain of Lakes and the North and South Branches of the Moose River.

CONTENTS

ACKNOWLEDGMENTS

The Town of Webb Historical Association in Old Forge, New York, has an extraordinary collection of photographs and a comprehensive research library. Unless otherwise noted, all of the photographs presented in *Old Forge and the Fulton Chain of Lakes* come from the association's collection. We are indebted to executive director Gail Murray and administrative assistant Kate Lewis for their cheerful help in the preparation of this book. All royalties from the sale of the book will be donated to this venerable institution. In addition, we extend our sincere thanks to Charles Herr, president of the Inlet Historical Society, for his valuable assistance researching the text for the lakes in the upper Fulton Chain.

—Linda Cohen and Peg Masters

INTRODUCTION

In this Venice of the woods, highways are rivers, paths are streams, and carriages are boats.

—*Adirondack Guidebook*, William Murray, 1870

In 1792, Alexander McComb purchased a patent from the state for 2 million acres of land in northern New York. John Brown of Providence, Rhode Island, acquired a 210,000-acre parcel that encompassed the Moose River territory in McComb's Purchase in 1798. Brown hired surveyors to map the region and divide the tract into eight townships. To encourage settlers, he had a dam built on the Middle Branch of the Moose River in Township 7, present-day Old Forge, to provide power for a gristmill and a sawmill. A handful of hearty pioneer families came by oxcarts over a primitive 25-mile road to clear the forests for farms and build the first dwellings in what is still called Brown's Tract. John Brown's untimely death in 1803 turned over the destiny of the settlement to his descendants.

A historic milestone was achieved in 1811, when the state legislature passed the Act for the Improvement of the Internal Navigation of the State for the purpose of establishing a communication by means of Canal Navigation between the Great Lakes and the Hudson River. Steamboat inventor Robert Fulton was assigned to investigate the feasibility of constructing a canal along the western corridor of the northern wilderness from the Mohawk Valley in Central New York to the St. Lawrence River. Fulton wrote an enthusiastic report of his journey through Brown's Tract along an unnamed chain of lakes. Although a canal route was deemed unsuitable due to various overland "carries" between the waterways, the eight lakes formed by the Moose River that he identified have since been known as the Fulton Chain.

John Brown's son-in-law, Charles Frederick Herreshoff, also came to Brown's Tract in 1811 and found the settlement largely abandoned and the gristmill and sawmill in disrepair. He built a substantial manor house overlooking the Moose River but soon discovered the climate was too harsh for farming. An attempt to process iron ore also proved futile. Plagued with enormous debts, Herreshoff took his own life in December 1819. The location of his "old forge" just below the dam on the Moose River became a meeting place for trappers, sportsmen, and their guides and a place name on New York State maps in the latter part of the 19th century.

Old Forge and the Fulton Chain of Lakes pictorially chronicles the permanent settlement of the Moose River region. It begins in the post–Civil War era when enthusiastic sportsmen and their guides wandered freely through the lush mountains and along the waterways in search of game, respite, and camaraderie. Primitive transportation allowed only the hale and hearty into their paradise and held the lumbermen at bay.

All that changed dramatically in 1891–1892 with the construction of the Mohawk and Malone Railroad through the western corridor of the Adirondacks by Dr. William Seward Webb. Dependable transportation brought thousands of new visitors to Old Forge, including influential governors,

judges, cabinet members, and captains of industry, who attached their Pullman cars to the regular passenger trains. Some of these notable sportsmen banned together and established private hunting clubs, while others bought large tracts for private estates, known today as "Adirondack Great Camps." The demand for elaborate cottages and resort hotels in the Fulton Chain region led to year-round employment.

Many of the photographs in *Old Forge and the Fulton Chain of Lakes* highlight the vintage structures that were built by pioneer families for homes and resort businesses as well as the camps, lodges, and hotels that accommodated seasonal residents and visitors. Over the years, a number of historic structures have succumbed to fire. Other privately owned landmarks, such as the grand hotels, have been torn down due to the changing lifestyles of vacationers. Paradoxically, the state-owned land surrounding Old Forge today, purchased or reclaimed because of delinquent back taxes, is now a rejuvenated woodland paradise and a wildlife habitat that offers unlimited recreational opportunities. In accordance with the "Forever Wild" clause in the state constitution, structures deemed nonconforming to the wilderness have been removed.

David Beetle, a regional author, wrote in the 1940s, "The Moose flows through so many lakes that most people have forgotten that it is a river." For nearly 200 years, the eight lakes in the Middle Branch of the Moose River have been called the Fulton Chain of Lakes. While Old Forge is the most populated community on the chain of lakes, its growth has been intrinsically linked to the industries, resorts, and settlers along the river's North and South Branches, as shown in many photographs in chapters two and five of the book. Also included are intriguing images and stories of the various recreational youth camps that brought, and continue to bring, thousands of urban children to the region. Their summer visits strengthen their physical and mental well-being, create lifelong friendships, and help establish an enduring appreciation for the natural beauty of the Adirondack Park.

While many of the photographs in this book emphasize the historically built environment, images of individuals and groups have been included to express the ingenuity, perseverance, and humor of the people who have shaped the history of the region. With an economy largely based on tourism today, the unpredictable climate that halted permanent settlement two centuries ago continues to present challenges to the nearly 1,200 full-time residents of Old Forge. A nostalgic look at the fine old heritage that descends from our woodsmen founders helps to guide the people of the Fulton Chain region through the challenges of the 21st century.

One

OLD FORGE

AN ADIRONDACK WILDERNESS SETTLEMENT

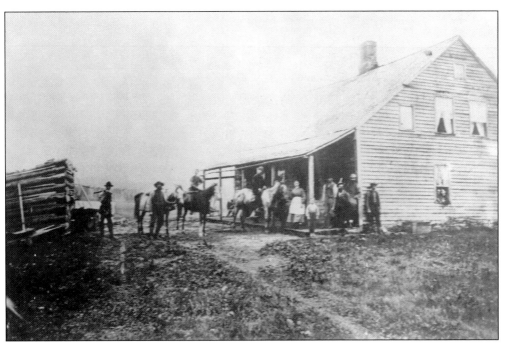

The Otis Arnold house overlooked the Moose River in present-day Thendara and was the first known 19th-century hostelry in the region. For more than 40 years, the Arnolds provided room and board, supplies, packhorses, and hunting dogs to trappers, guides, and sportsmen. Originally called the Manor House, it was built in the early 1800s by Charles Frederick Herreshoff, who established an "old forge" along the river.

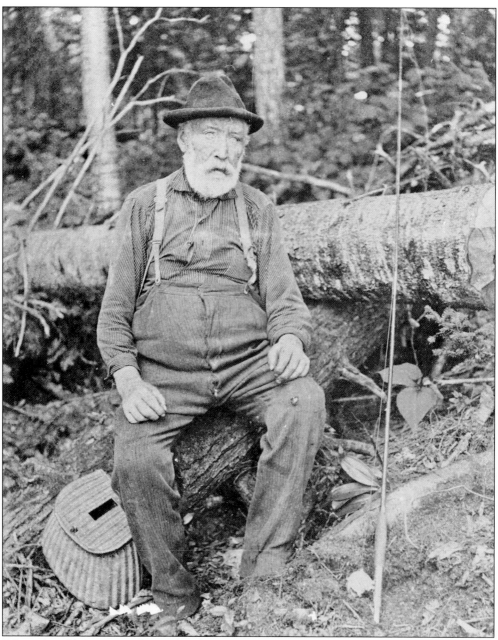

Edwin Arnold (1829–1906) was the eldest son of Otis and Amy Arnold's 12 children. His 10 sisters helped their mother with household duties, hospitality, and farming chores, while the men folk hunted, trapped, and guided visitors. A few years after the 1869 suicide death of his father, Otis, Ed established a public camp on the South Shore of Fourth Lake, known today as Cohasset Point. Ed Arnold's knowledge of woods lore was unsurpassed, and his jovial bewhiskered face and well-fed figure was a characteristic feature of the mountain landscape for decades.

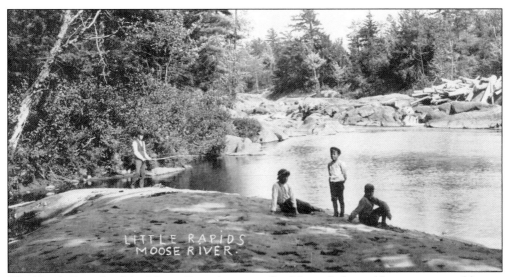

The North Branch of the Moose River begins at Big Moose Lake and becomes navigable as a popular canoe route near Rondaxe Lake. It joins the Middle Branch at Old Forge. The South Branch begins in the remote Moose River Plains, flows through the Adirondack League Club Preserve, and joins the other branches near McKeever.

Chief Jules Dennis and other Abenaki Native Americans from the Odanak Reserve near Quebec spent their summers along Fourth Lake in the 1890s selling ash-splint and sweetgrass baskets, birchbark canoes, snowshoes, and other fine handcrafted items to hotel guests. Chief Dennis (left) and his family became full-time residents of Old Forge, and his descendants still reside in the community.

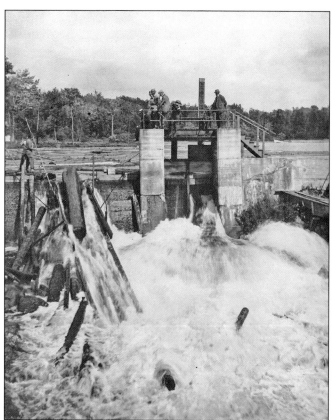

Tract owner John Brown built the dam at Old Forge in 1799 to power the first settlement's gristmill and sawmill. By 1880, the dam came under state control. It lies at the foot of the eight lakes along the Middle Branch of the Moose River, which has been known as the Fulton Chain since steamboat builder Robert Fulton explored the region in the early part of the 19th century.

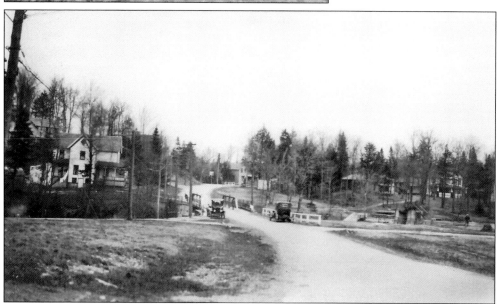

John C. Woodruff served as the state dam tender from 1897 to 1911. He is credited with building the residence on the left, still known as "the dam house." In 1982, the dwelling was turned over by the state to the Town of Webb for $1. The dam house is now privately owned and has undergone significant restoration in keeping with its 19th-century character.

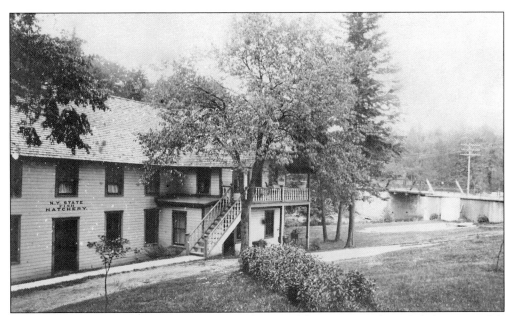

In the early 1870s, Emmett Marks transported 10,000 lake trout eggs from Caledonia to a fish hatchery, financed by a sportsmen's club from Boonville, on the Fulton Chain. The state moved the hatchery building to near the dam in Old Forge a few years later. In 1935, the State Conservation Department cited Emmett Marks as the "Godfather of Adirondack Fishermen" for his pioneer work as a fish culturist.

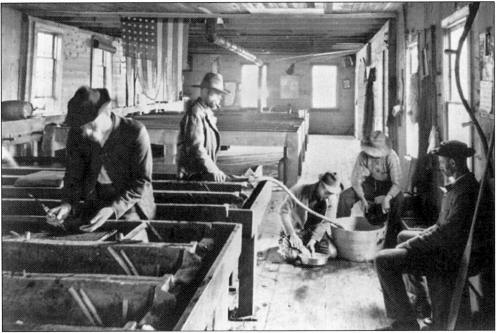

These men are hard at work propagating lake and brook trout inside the Old Forge hatchery. Local officials negotiated in 1936 to purchase the property after the state closed the facility. The building was renovated over the next several years for use as the town hall, jailhouse, and community center. Today it is the headquarters for the Covey-Pashley American Legion Post No. 893.

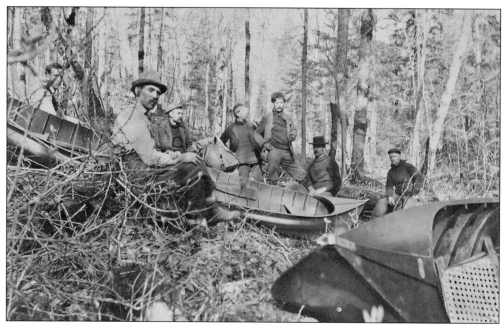

Verplanck Colvin served as superintendent of New York Land Surveys from 1872 to 1900. His annual reports helped to persuade the state legislators to preserve the great northern wilderness now known as the Adirondack Park. Colvin's work would not have been possible without the help of local guides. This photograph of guides on a survey detail includes Old Forge settler Peter Rivet in the foreground.

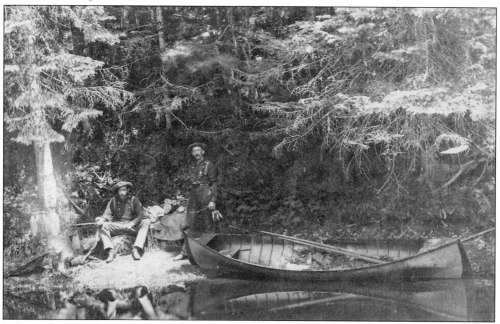

Fulton Chain guides pioneered the settlement of Old Forge. They possessed essential survival skills and were versatile and energetic. These two outdoorsmen pause for a rest by their guide boat while out fishing along the Fulton Chain. Both are clothed in button-topped wool shirts and trousers with suspenders, the traditional outfit worn by North Country guides.

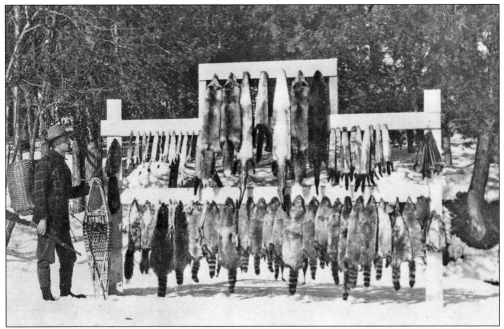

In winter, trapping fur-bearing animals was a good source of income for many local guides. It was frequently a first job for young boys. Maintaining a trapline is difficult and demanding. Snowshoes and packbaskets are important tools of the trade. The large number of pelts shown here are fox, raccoon, beaver, mink, and ermine.

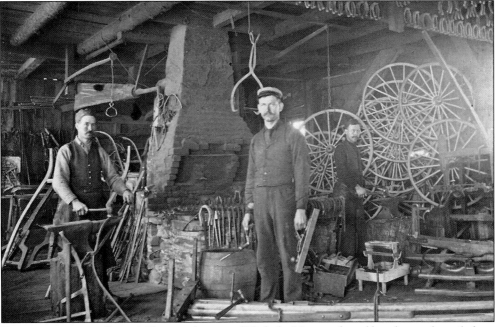

Two centuries ago, a Brown's Tract settler named Nicholas Vincent forged hand-wrought nails from local iron. During the days of horse and buggies, blacksmiths provided essential services to their communities. They made horseshoes, wagon wheels, sleigh runners, tools, and other household items. Oscar K. Garber (left) is the only blacksmith identified in this local shop.

Dr. William Seward Webb and Lila Vanderbilt, the youngest daughter of William H. Vanderbilt, were married in a high-society wedding in December 1881 and honeymooned in Montreal, where the photograph at left was taken. Webb financed and supervised the construction of the 191-mile Mohawk and Malone Railroad through the western Adirondacks in 1892. In his honor, the entire northern part of Herkimer County was renamed the Town of Webb in 1896. Below is Forest Lodge, built in 1892, on Dr. Webb's 40,000-acre private estate called Ne-Ha-Sa-Ne, located along the railroad corridor. On August 3, 1926, Dr. Webb signed the guest book at the lodge for the last time. He died at his home in Vermont two months later. At the foot of his grave is a boulder from Ne-Ha-Sa-Ne, his much loved home in the Adirondacks.

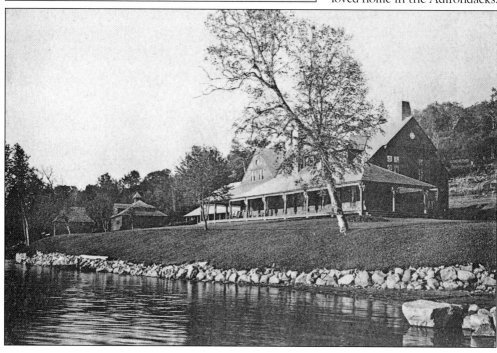

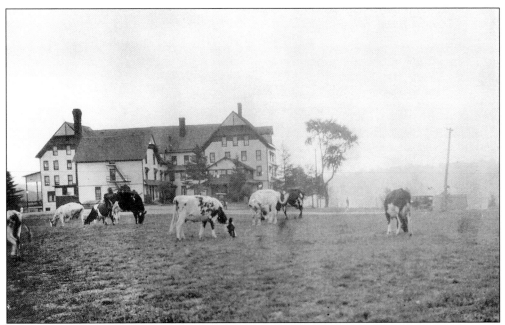

The original Forge House log structure was built in 1871. Dr. Alexander Crosby and Samuel Garmon of Lewis County purchased the hotel in 1888 and erected the first of several additions. An 1891 visitor described the building as a large, yellow frame hotel that "looked as much out of place as a cab in the heart of the Desert of Sahara." The cows provided fresh dairy products for guests.

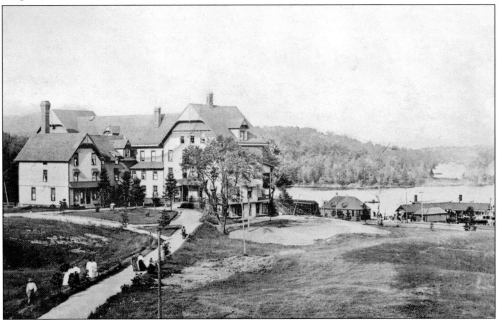

For more than half a century, the Forge House overlooked the Old Forge waterfront. From the broad verandas, guests had a sweeping view of the steamboat docks and the 2-mile spur railroad that brought passengers from the Mohawk and Malone Railroad station south of town. The hotel was destroyed by fire in 1924.

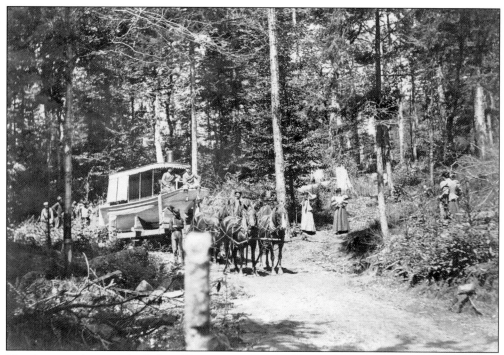

The first steamboat on the Fulton Chain was called the *Hunter*. It was built in Boonville in 1883 for Capt. Jonathan Meeker by his brother-in-law, H. Dwight Grant, and hauled to Old Forge. Captain Meeker and his wife, Harriet, operated one of the first 19th-century public boarding camps near the head of Fourth Lake.

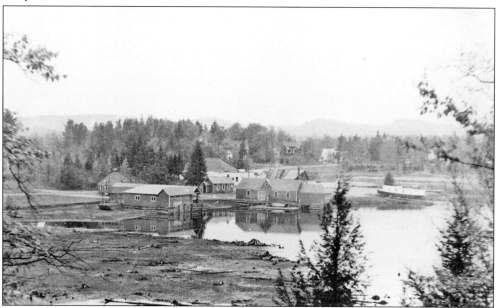

In 1919, the state turned over control of the dams at Old Forge and Sixth Lake to the Black River Regulating Commission. Drawing down the reservoirs during the summer months, illustrated here by the appearance of an island in Old Forge Pond, interfered with safe navigation on the lakes and infuriated Fulton Chain hotel and camp owners.

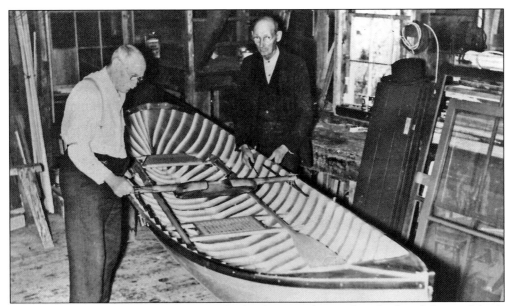

Ben Parsons (left) and his brother Ira put the finishing touches on their final guide boat in March 1941. It weighed 68 pounds, including the seats, oars, and yoke. They began making boats in 1889 at Old Forge after learning the craft from their father, Riley Parsons, who worked with master boatbuilder H. Dwight Grant in Boonville.

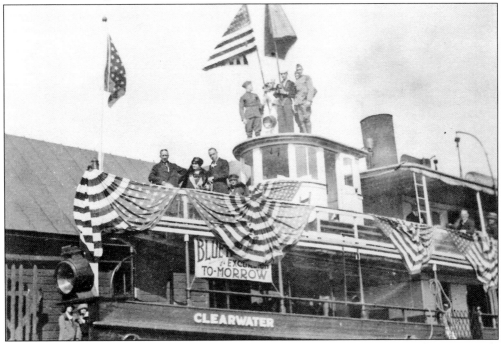

Old Forge provided a rousing reception for Gov. Alfred E. Smith and his wife, Catherine, on July 22, 1923. The American Legion band escorted him to the *Clearwater*, the queen of all steamboats on the Fulton Chain. The American flag the governor presented to the legion was hoisted above the top deck. Smith's popularity with local residents was attributed to his support for a new highway connecting Old Forge to Eagle Bay.

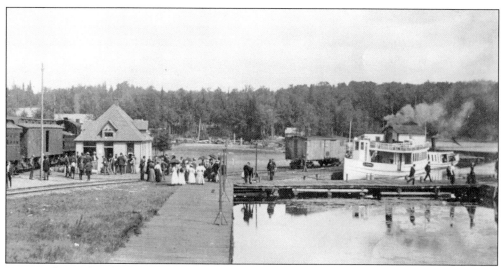

Victor Adams of Little Falls spearheaded the construction of the Fulton Chain Railroad in 1896 to bring passengers from the Mohawk and Malone Railroad station 2 miles south of town to the steamboat docks at the Old Forge waterfront. Dr. William Seward Webb and his associates with the New York Central Railroad purchased the spur railroad and the Crosby Navigation Company's steamboats in 1901 for a reported $45,000.

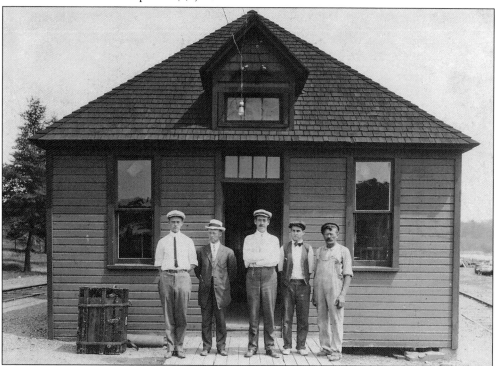

The Fulton Chain Railroad employees identified in front of the station house at the waterfront are, from left to right, Walt Miller, Hal Abbott, Maurice Callahan, William Christy, and Paul Huguenin. The 2-mile-long spur railroad tracks were torn out in the early 1930s. The route is now part of the TOBIE (Thendara, Old Forge, Big Moose, Inlet, and Eagle Bay) bike and walking trail along Park Avenue in the village.

In 1917, shortly after Pres. Woodrow Wilson announced the U.S. Declaration of War against Germany, the citizens of Old Forge gathered for a patriotic parade and flag-raising ceremony at the Busy Corner. Participants included the schoolchildren, Legionnaires, Herkimer County dignitaries, and a band. The three structures to the left of the flagpole are the Covey Block, Barker's store, and Abbott's post office.

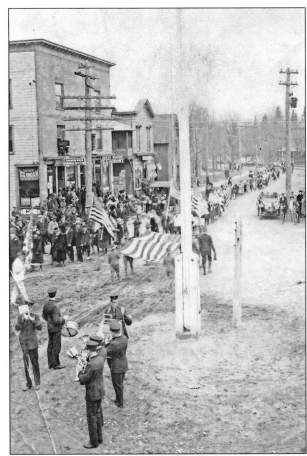

This view of the 1917 patriotic parade shows the construction of the First National Bank built by local contractor Arthur Stowell. The Wood, Harney, and Winterbotham store is adjacent to the bank. William Thistlethwaite's Adirondack Development Company office roof provided several spectators with a bird's-eye view of the festivities. All three buildings have survived, although Thistlethwaite's stucco office building is presently a private residence on Crosby Boulevard.

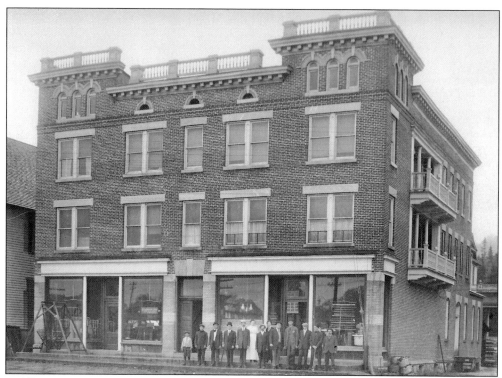

Peddler Moses Asher Cohen (the short man at center) came to Old Forge in 1900. He opened the Old Forge Hardware in a rented room in the basement of the Forge House. In 1903, he erected this very substantial emporium at the corner of Fulton Street and Crosby Boulevard. The Old Forge Hardware has been a favorite destination for visitors for more than a century.

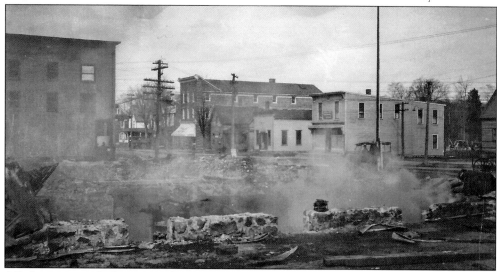

All that remained of Moses Cohen's Old Forge Hardware after it burned in May 1922 was a smoldering rubble stone foundation. Paints, turpentine, dynamite, and even exploding bullets in the store fueled the disastrous fire that started in a pool hall next door. Local firefighters responded with their hand-pulled pumper and hose cart to save the Berkowitz store across the street as well as other buildings near the Busy Corner.

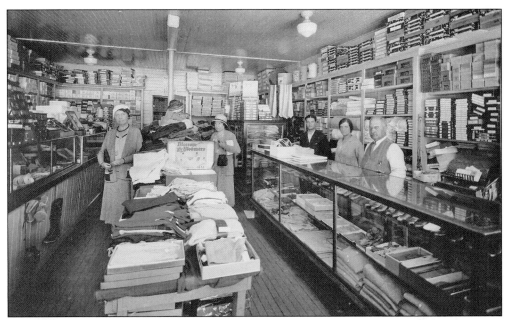

Moses Richbook purchased a Busy Corner lot from Crosby and Garmon's Old Forge Company in 1898 and built a dry goods store that he sold in 1907 to Harry L. and Dora Perlman Berkowitz. Harry poses for this photograph behind the counter with his son Hyman and daughter Gertrude. The landmark building faced demolition in 2003 but was purchased and completely rehabilitated by a local developer.

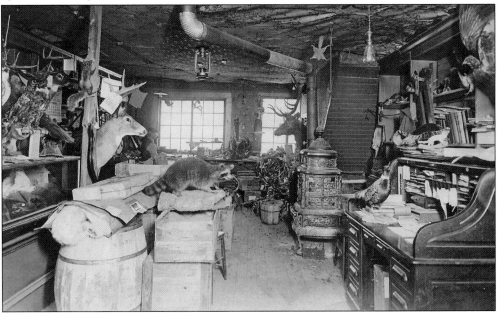

Artemus M. Church, a veteran Fulton Chain guide, was elected as secretary and treasurer of the Brown's Tract Guides' Association in 1898 and served in that position for 17 years. He was also one of the most respected taxidermists in the Adirondacks. His mounted trophies were shipped all over the states. This photograph from the early 1900s shows the interior of Church's taxidermy shop on Main Street.

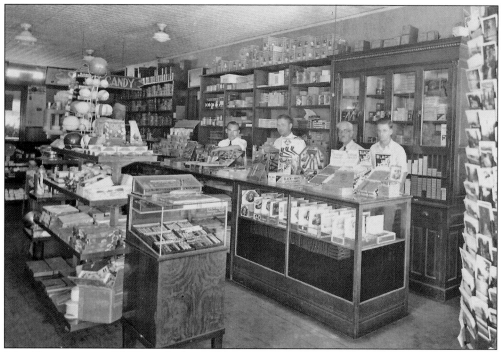

John Given came to Old Forge for his wife Henrietta's health and established a drugstore at the Busy Corner. This interior photograph includes Given and his son-in-law, Edwin Boylan. Edwin, a graduate of the Albany School of Pharmacy in 1925, sold the business to his son John Boylan in 1966. The Given-Boylan Block was nearly destroyed by a fire in 1990. Today a retail store occupies the remaining one-story structure.

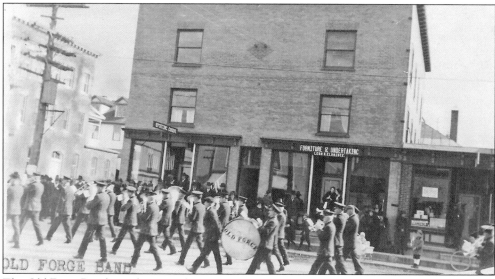

The Old Forge Band marches past the Covey Block, where Leon and Alice Eldridge established the community's first undertaking business in 1918. Perhaps unsure of its success, they also sold rustic camp furniture. The family later moved the funeral home to Fern Avenue and operated the business until Alice's death in 1968. The Covey Block succumbed to fire in October 1942. (Courtesy of Ed Diamond.)

German-born Edward J. A. Lenhardt erected the Lenhardt Bakery in 1909. In the 1920s, Edward served as the president of the Old Forge village board. The vintage brick structure has housed many retail businesses during the past century, including the Grand Union Grocery Store shown here. It is presently the home of a popular Main Street café.

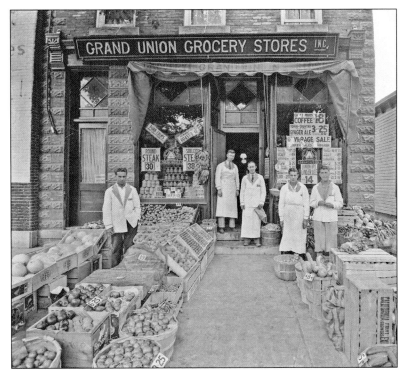

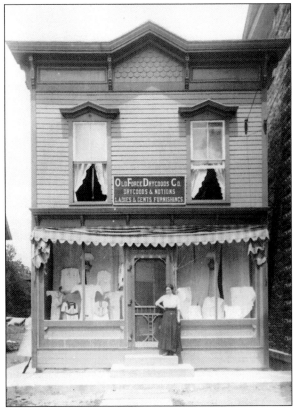

Peter Rivet came to the North Woods as a guide in the early 1880s. He married Margaret Branagh in 1891, and they raised a large family. Margaret opened the Old Forge Dry Goods store next to the Lenhardt Bakery. Daughter Frances is pictured around 1910. The business was later moved just beyond the Old Forge Hardware, and the Rivet store is now incorporated into that emporium.

When a survey showed nearly 150 people were attending Sunday services at the new school in 1896, the Utica Presbytery decided to build a mission church in Old Forge. Victor Adams, president of the Old Forge Company, donated a $500 lot on Crosby Boulevard. Elmer J. Adams of Lyons Falls completed construction of the church in 1897. Adams also built the double-gabled manse next door the following year.

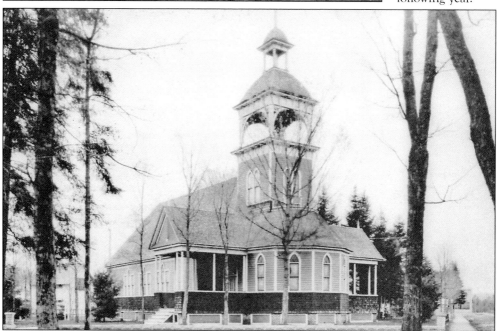

Fr. Hugh N. Byrnes held the first Catholic Mass on February 19, 1895, at the Harvey residence, the former Adirondack Bank building on Codling Street. After two years of fund-raising, St. Bartholomew's Church was completed under the supervision of architect Levi Deis of Old Forge. The stately wooden structure survived more than nine decades at the corner of Crosby Boulevard and Park Avenue. It was replaced with a new church in 1991.

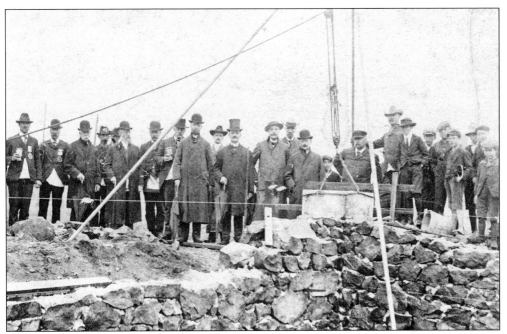

Members of the North Woods Masonic Lodge gathered in the spring of 1905 for the ground-breaking ceremony of their new building on the east side of Crosby Boulevard. The massive structure included a grand hall on the first floor and banquet and lodge rooms in the upper story. The contractor was Elmer J. Adams of Lyons Falls.

The Masonic Lodge was available, as it is today, for social and fund-raising community events. Moving pictures were shown here as early as 1908, and bowling lanes were also installed in the building. The lodge was expanded in 1922 and has undergone various renovations over the years, but still retains many of the architectural features of its original design from a century ago.

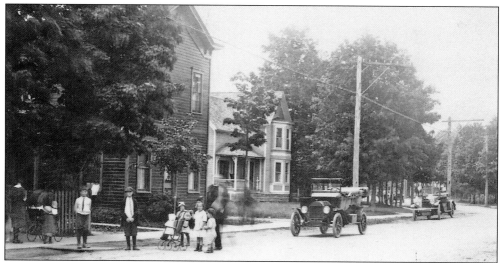

These well-dressed children are strolling on Main Street in front of the Edmund Abbott residence and post office. Abbott came to Old Forge from Forestport in 1892 and established a mercantile business in the same block. To the right of Abbott's is the home of Dr. Robert S. Lindsay, who started his practice at Old Forge in 1904. The Lindsay residence houses a retail business today and remains remarkably unchanged.

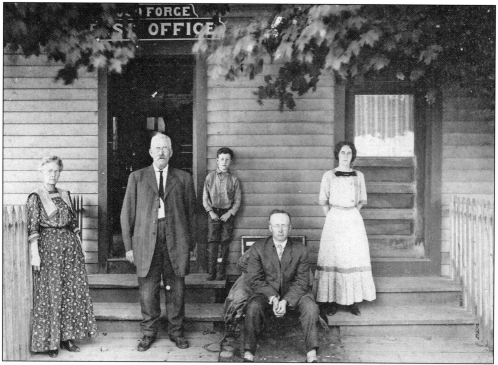

Communities often marked their origin by the establishment of a post office. Charles Barrett was appointed the first postmaster of Old Forge in 1883. Edmund Abbott served as the fifth postmaster from 1897 until his death in 1918. Abbott poses in front of the post office building he constructed in 1901 with his wife, Lucy Abbott (left); nephew Dean Luther (seated); and the Abbott children, Harold and Louella.

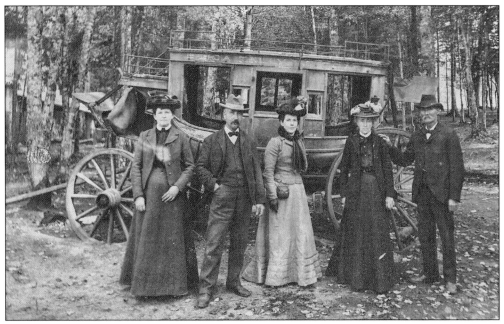

Edward "Daddy" Doolan and his wife, Mary, stand to the right in front of this Tallyho coach. They were married in 1900, the same year they bought the Forest House on Main Street from Bessie A. Nichols. Childless and very religious, the Doolans took in many tuberculosis patients when other hotels refused them care. Edward also provided horse-drawn taxi services from the train depot to Old Forge.

Two German-born sisters, Anna and Sophia Burkhart, came to Old Forge in the 1890s. Sophia, leaning on the porch post in the background near her husband, Adam Tennis, was the proprietress of this Main Street tourist home called the Adirondack House. Anna and her husband, Jacob Kline, a stonemason, erected a residence across the street. Both structures, built in 1898, survive to this day and contribute to the historical character of downtown.

Samuel A. Smith operated a livery business in Old Forge before building the artistic Moose Head Hotel in a grove of trees on Main Street in 1908. His wife, Isabelle, died in June 1910, shortly after the birth of twins Ernest and Lena. The hotel in the background was a favorite residence for Old Forge teachers. It was destroyed by fire and reopened in 1922 as the New Moose Head Hotel by Samuel's second wife, Eliza Helmer.

Dwight Bacon Sperry put up this three-story brick building in 1902 for his sister Daisy and her husband, William Glenn. The contractor was William R. Rich from Lowville who also built the Glennmore hotel for Sperry in 1899. The store was sold when Daisy (left) had a reoccurrence of tuberculosis in 1917. The Glenn Block has housed retail businesses on Main Street for more than a century.

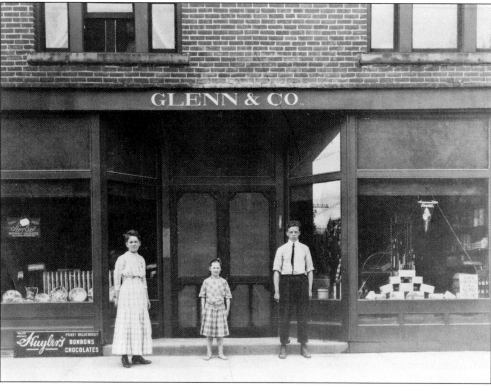

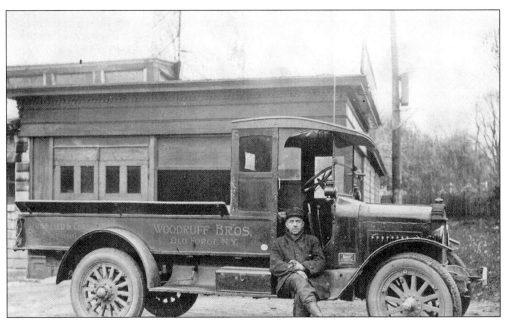

Fred C. Woodruff, with his sons Clarke and Carleton, conducted a coal and ice business in Old Forge until his untimely death in 1928 at age 51. Their Stewart truck picked up supplies in Utica and made deliveries as far north as Raquette Lake. The Woodruff's Main Street home, originally built by Adirondack guide William Sperry, is a flower and gift shop today.

Thomas Wallace moved his blacksmith business from Forestport to Old Forge in 1899. Thomas and his wife, Beatrice, raised a large family in their home at the corner of Main and Gilbert Streets across from the school. He is the chauffeur in this 1917 patriotic parade photograph, with Marg Given in the backseat. The Wallace homestead and blacksmith shop survive in this historic part of town.

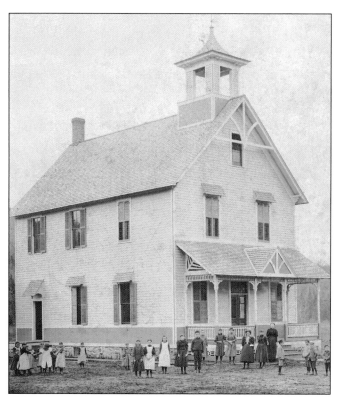

The first schoolhouse in Old Forge cost the residents $3,000. It was built at the corner of Main and Gilbert Streets in 1896, and 40 students were enrolled. Mae Sperry, the first teacher at the school, assembled a group of her students for the charming photograph at left. A larger schoolhouse was constructed adjacent to this building in 1907 to accommodate increased enrollment. On a frigid night in February 1912, the fire bell was pulled, alerting the hook-and-ladder company men that the new school was ablaze. Nothing was saved but a few books and the principal's desk. For the next two years, students attended classes at various places around town, including this group below at the Masonic Lodge on Crosby Boulevard.

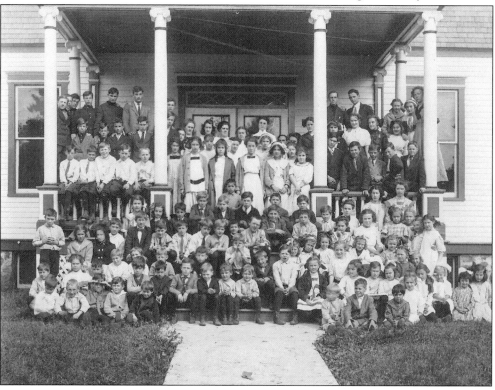

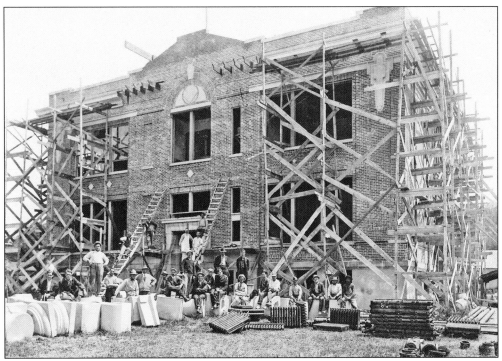

The school board reviewed several architectural plans and selected the proposal submitted by Walter D. Frank of Utica. In March 1912, he estimated the cost would be $34,000. This photograph shows the new neoclassical brick school under construction. Town of Webb students still walk the building's hallowed halls on the same site where academics began in Old Forge more than a century ago. (Courtesy of Ed Diamond.)

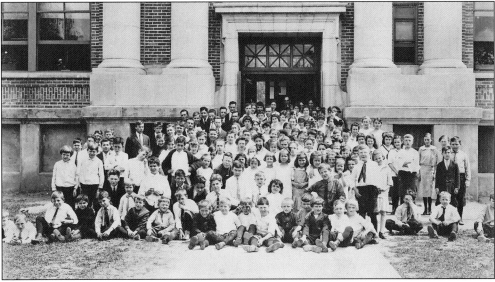

Old Forge was one of the first schools in the state to offer a kindergarten program and hot lunches. In the 1980s, former kindergarten teacher Anna Gorman was able to identify two Sperry brothers, a Rivette, a Deis, a Burdick, and A. Richard Cohen (first row, third from the right) among the students in this 1914 photograph taken in front of the new school.

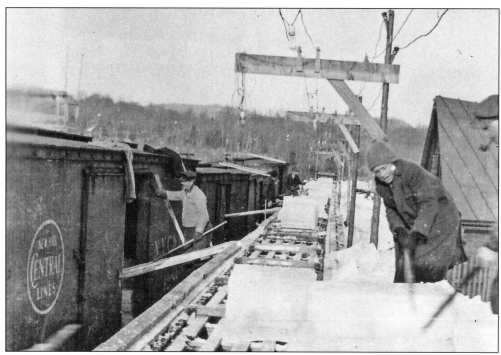

Ice harvesting began in earnest in the late 19th century when the railroad reached the Old Forge waterfront. The ice was cleared of snow, and a grid was drawn. Uniform-sized pieces were cut by hand in the early years. Channels were opened to float the ice blocks to shore and then loaded directly into railroad boxcars, as seen above, for delivery up and down the East Coast. The steamers *Clearwater* and *Nehasane* are in dry dock next to the Forge House in the photograph below. Local men conducted smaller ice-harvesting operations for the hotels and camps and packed the blocks with sawdust in icehouses. One of the few remaining icehouses in Old Forge has been restored and is located behind the Town of Webb Historical Association's Goodsell Museum on Main Street.

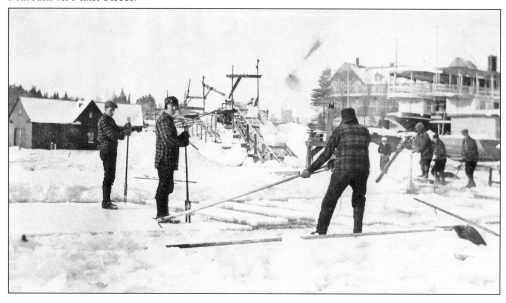

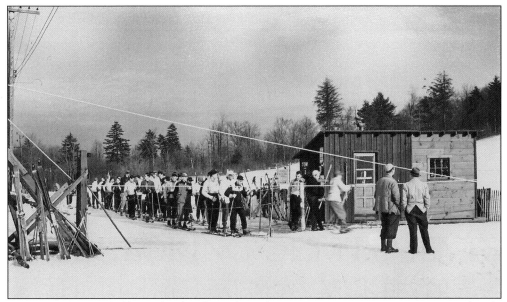

The 1932 Olympics held in Lake Placid popularized winter sports. During many winter weekends, beginning in the 1930s, snow trains arrived at the Thendara station with hundreds of skiers. The visitors were transferred to the Maple Ridge Ski Center on the south side of Park Avenue. There a rope tow dragged the hearty athletes to the top. It cost a penny a ride but schoolchildren rode for free.

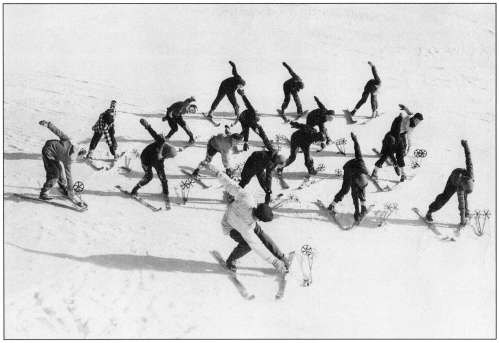

Ski instructor Max Bolli leads a group of skiers in warm-up exercises. Bolli was born in Switzerland and came to the United States in 1930. He moved to Old Forge in 1937 to establish a ski school and helped to lay out slalom, downhill, and cross-country trails at Maple Ridge and McCauley Mountain. The well-loved instructor died at age 63 in 1968.

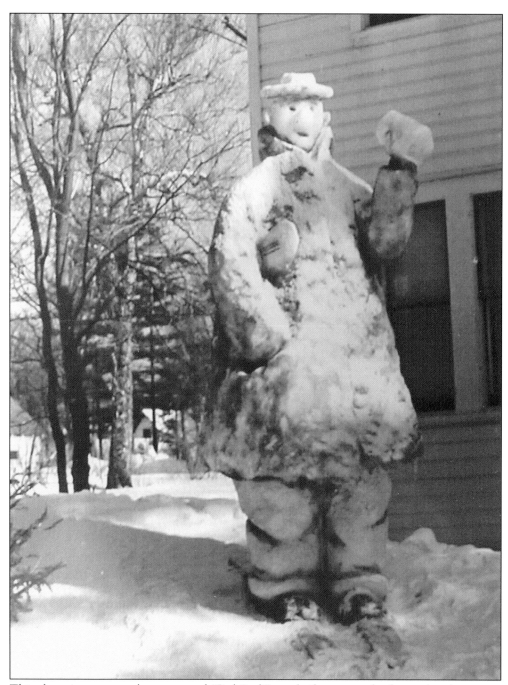

This charming snow sculpture named "Sad Sack" was built next to the former band room on Main Street by several Town of Webb teachers, including Al Stipp, Dave Clark, and Bob Lindsay. Mr. Sack stood on snow skis and was nearly as tall as the telephone wires. Winter carnivals have been a tradition in Old Forge for decades. The Polar Bear Ski Club organized the events for many years, with assistance from the Winter Sports Association, Lions Club, Town of Webb, and other local groups. Legend has it that Sad Sack's creators were hoping to win the $10 prize money for some refreshing beverages.

Two

NEIGHBORING SETTLEMENTS
FROM THENDARA TO MCKEEVER

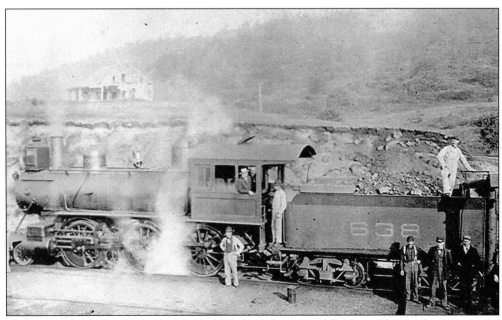

Rail service arrived at the outskirts of Old Forge in July 1892. The Arnold's hostelry, seen in the background, succumbed to a mysterious fire in 1895, which only added to its legendary significance to local history. This chapter takes a look at the Moose River hamlets south of Old Forge along the rail corridor that were inalterably affected by the arrival of the iron horse in the wilderness.

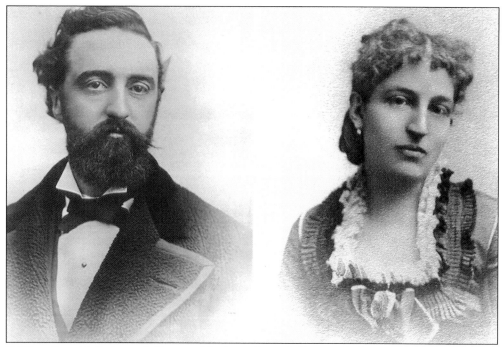

William S. and Julia Lyon deCamp trekked into Brown's Tract with their son in a packbasket in 1887. They hired local guides to build a summer camp on the island between First and Second Lakes, still known as deCamp Island. Soon after, they set up a mill and lumbering operations near Arnold's at Fulton Chain.

Julia deCamp inherited 17,000 acres along the Moose River from her father's estate in 1869. Determined to improve transportation to her tract, the deCamps launched this paddle-wheel steamer, the *Fawn*, on the Moose River 6 miles below Old Forge near Minnehaha in 1889. Although Julia died just six years later, her descendants continue to shape the development of the Old Forge region today.

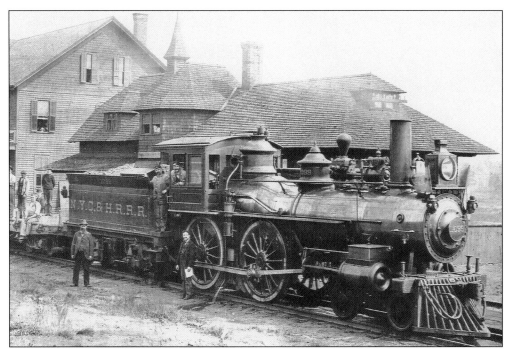

Dr. William Seward Webb's railroad was called the Mohawk and Malone (M&M) for many years. The Vanderbilts took over operations in 1893, and the Adirondack Division of the New York Central Railroad appeared on subsequent timetables. A water pump on top of this locomotive indicates this was a work train used to fight forest fires along the corridor. Sparks from the smokestacks frequently landed on the Mack's Hotel roof next door.

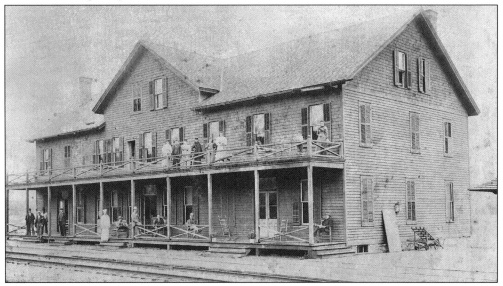

Rome contractors Nelson C. Neice and E. Melville Moose built this hotel in 1893 for Cornelius Mack. In July 1905, the Tennis brothers hired Nick Ginther to move the hotel across the tracks with a team of horses. They sold it to Charles Van Auken in 1908 for a reported $21,000. Van Auken's Inne continues to overlook the historic station just as it did when Charles owned it a century ago.

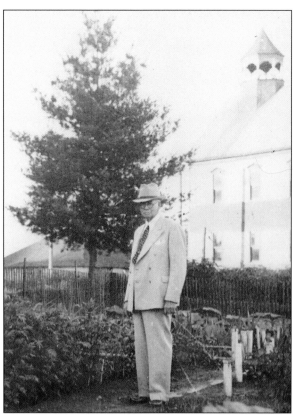

Charles Van Auken is standing in his vegetable garden adjacent to the Fulton Chain Town Hall. Van Auken's Tavern catered to an upscale clientele and hosted many American and foreign dignitaries. When a post office was established at Fulton Chain in 1897, Van Auken was appointed the first postmaster. He later served as town supervisor and owned a construction firm that built highways all over the northeast.

Levi Deis designed the town hall that was built in 1900 on land donated by William S. deCamp. It was the center of community events, including performances on the second floor stage, for nearly half a century. The Thendara town hall still has the stage, original tin ceilings, and voting booths. The building, abandoned for many years, is now owned and being restored by Julia and William S. deCamp's great-grandson, Stuart deCamp.

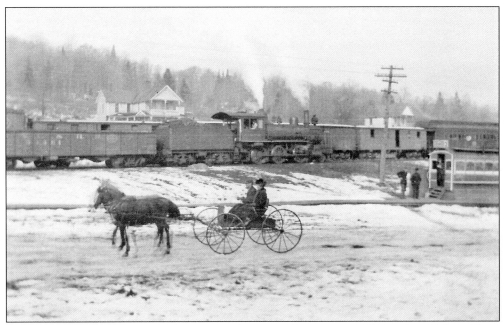

This couple appears oblivious to the trainmen's stares as they jaunt past the tracks at Fulton Chain in their horse-drawn carriage. Theodore Seeber, a local boatbuilder, estimated annual visitors jumped from 2,000 people per year in 1889, when he moved to Brown's Tract, to nearly 25,000 by 1896 due to dependable, year-round transportation on the trains.

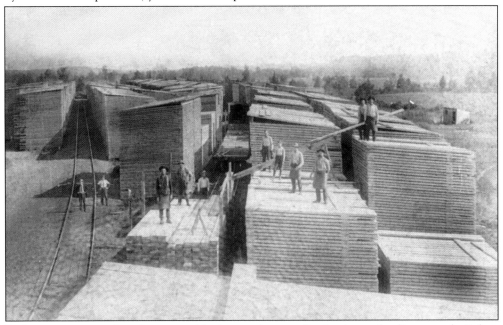

Railway tourists must have been astonished to see the sprawling lumberyards adjacent to the Fulton Chain station. The population in 1900, mostly first-generation French Canadian lumberjacks and mill workers, was nearly as large as Old Forge 2 miles upriver. In addition to three mills, the bilingual community had several boardinghouses, two hotels, a store, a bottling factory, and 50 students in the one-room schoolhouse.

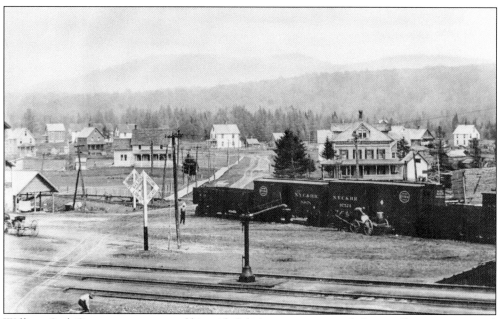

William S. deCamp, as executor of his wife Julia's estate, managed their mill operations until his death in 1905. In 1901, deCamp built 17 houses in this vista to accommodate his employees. The prominent structure in the center is the 1895 deCamp homestead. Today it is a delightful bed and breakfast known as the Moose River House that is owned by William's great-grandson, Stuart deCamp.

A disastrous fire in 1916 destroyed the Brown's Tract mill in the heart of Fulton Chain. A bucket brigade was formed to save Van Auken's Tavern and the depot building. This is the first known photograph of Old Forge firefighters, who used dynamite to keep the blaze from spreading to the Deis Mill nearby. The fire company was organized in 1907.

The Wood-Foley-Harney store, next to the Fulton Chain station, catered to mill families, lumberjacks, and railroad employees. Patrick J. and Nellie McNally Foley were partners in the business from 1910 to 1919. Their children—from left to right, Mildred, John, James, William, and Arthur—are pictured outside of the store enjoying a pony ride in their wicker carriage.

The Tennis brothers—Peter, Jacob, and Adam—immigrated from Alsace-Lorraine in the 1890s. For several years, they operated this bottling works at Fulton Chain and the hotel that was sold to Charles Van Auken. This 1904 photograph shows Adam Tennis in the wagon and Peter Tennis next to the barrel on the porch of the bottling works building, which is a private residence today.

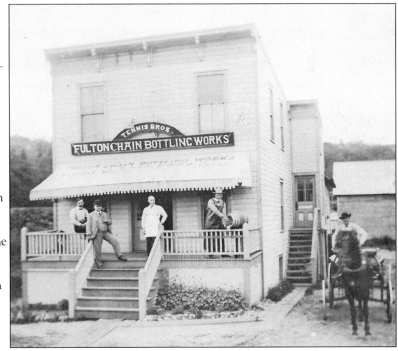

43

Two of Henry and Clara DeMoors children—Cecelia (left) and Melina—pose for this 1916 photograph near their home at Fulton Chain. Henry worked at the mills, and Clara was a cook at various hotels for many years. Cecelia, born in 1913 and still a resident of the community, generously shares her wealth of knowledge on early regional history. (Courtesy of Betty Rannels.)

This rare photograph from the late 1930s of a Civilian Conservation Corps (CCC) camp was provided by longtime resident Cecelia DeMoors Buckley. The camp was located near the railroad tracks in what was called the "Goose Pasture." A few years earlier, another CCC camp was established in the Joy Tract. CCC workers helped clear years of logging debris from the Moose River and cut many of today's popular hiking trails. (Courtesy of Cecelia DeMoors Buckley.)

CCC workers cut the trailhead near the railroad trestle to the Moose River Fire Tower in the 1930s. Former railroader Pete Walters was one of the memorable fire tower observers. The site became known as Pete's Tower because of his affable personality. The tower was deemed a nonconforming structure in the wilderness, and state workers pulled it down with a bulldozer in 1977.

On the right side of this 1918 photograph of the James Pullman home is the first state highway through the region. James was a master carpenter, and the Pullman Mill was located on the river adjacent to his residence. The Morley Watson family lived here for a number of years, and the home is remarkably unchanged today.

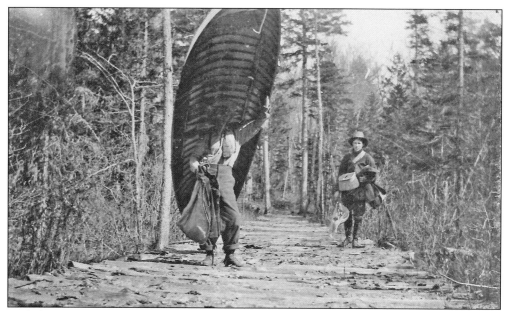

Nicholas Stoner was a veteran of the Continental Army, the War of 1812, and three marriages. The woodsman's favorite fishing spot was a pristine lake just beyond this corduroy road where these guides were photographed in 1897. Nicholas Stoner died in 1850. His unique story remains a part of local history because of Nick's Lake, the site of a beautiful state campground just a mile over the eastern hillside from Thendara.

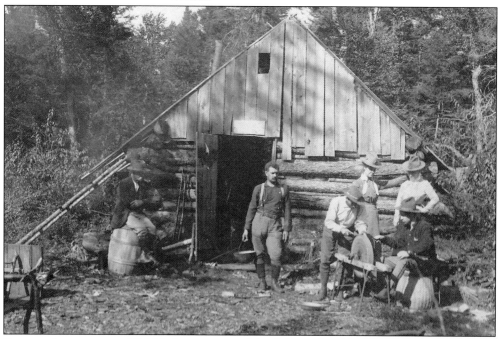

For more than a century, Nick's Lake was a part of the deCamp family's 17,000-acre tract. Squatters like this unidentified blacksmith inevitably took up residence along its shores. This photograph was taken of the blacksmith shop when an adventurous visitor, Mrs. Fulton, hiked to the lake with her guides—Phil Christy, George Stoddard, and James Hill.

Auto camping became popular in the Adirondacks after Thomas Edison's trips there in 1916 and 1919 with friends Harvey Firestone and naturalist John Burroughs. This camper was likely on his way to one of the nearby state campgrounds built by CCC workers in the 1930s. Nick's Lake was the last state campground established in the Old Forge area. In 1966, it opened with 114 tent and trailer sites.

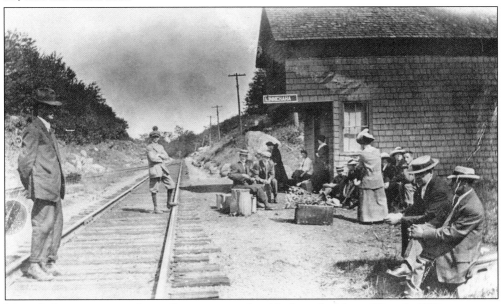

Minnehaha is a sportsmen's paradise near a set of rapids along the Moose River. In 1889, passengers disembarked here from the steamer *Fawn* to board the first railroad to enter Brown's Tract. Affectionately called the "Peg-Leg" because it traveled 8 miles over wooden rails, the novel line was discontinued shortly after this flag stop station on the Mohawk and Malone Railroad was established at Minnehaha in 1892.

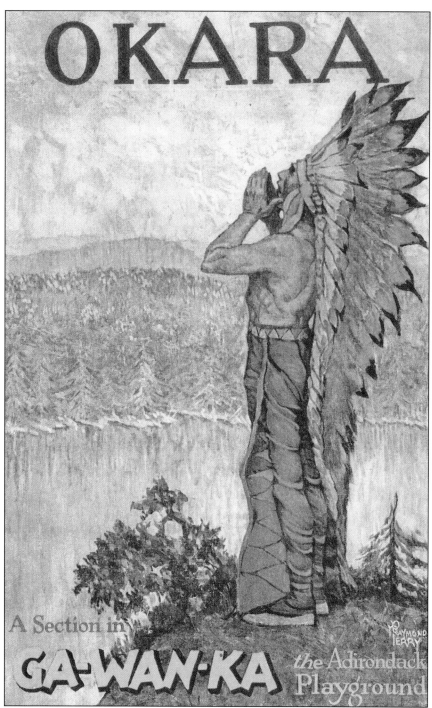

Lyon deCamp had a penchant for Iroquois names. In 1919, the family formed the Ga-Wan-Ka Corporation, which meant the "meeting place." Fulton Chain was renamed Thendara, meaning "rim of the forest." South of town, the Hellgate Ponds became the Okara Lakes, or "the eyes." Trainloads of prospective buyers viewed camp lots at Ga-Wan-Ka's 640-acre Okara tract and plans for Japanese-style cottages designed by New York City architect H. Van Buren Magonigle.

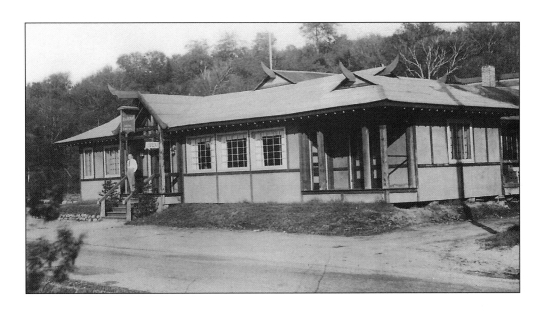

This teahouse illustrates the use of an upswing roofline and other oriental details typical of Magonigle's work at Okara. Similar features were incorporated into a $60,000 home he designed in 1916 for Horace deCamp. It was located, and still stands, on the peninsula between First and Second Lakes. The hand-drawn sketch below of Magonigle Camp was one of a dozen designs available to Okara buyers. "It took me three months of scrambling around the brush last summer to find the true Adirondack colors," Magonigle told a reporter in August 1920. Red roofs and yellow trim mimicked the scarlet maples and golden beeches of autumn. The vertical battens were stained gray-black like spruce bark after a rain. A handful of these unique cottages have survived to this day.

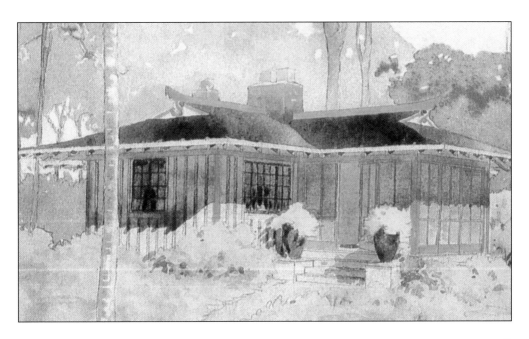

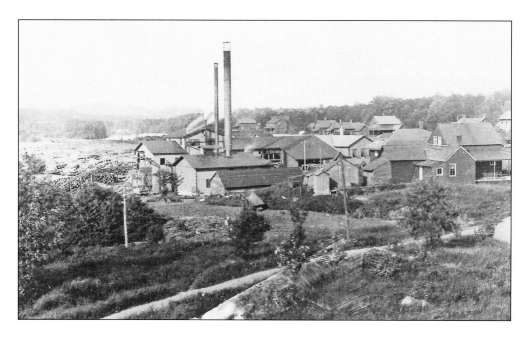

Ten miles south of Old Forge, where the Moose River branches unite en route to the Black River and Lake Ontario, is the former bustling mill town of McKeever. In December 1890, Lemon Thomson of Glens Falls purchased 15,225 acres of timberland in the Moose River Tract for $38,000 and erected a sawmill. His son-in-law, John A. Dix, took charge of mill operations. Dix was elected governor of New York in 1911. McKeever, shown above, was named for Dr. William Seward Webb's assistant superintendent R. Townsend McKeever, a nephew of his wife Lila. A large dam was built across the Moose River, forming the lake in the distance beyond the buildings. Near the dam, the three fearless boys below negotiate their boat through the logs destined for the mill.

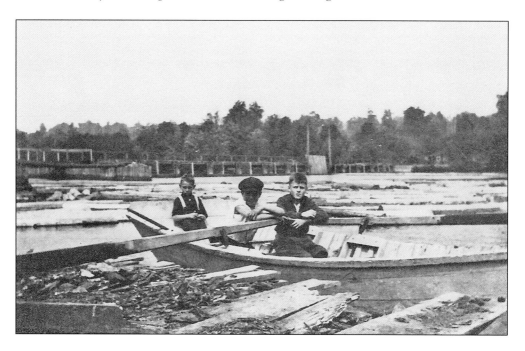

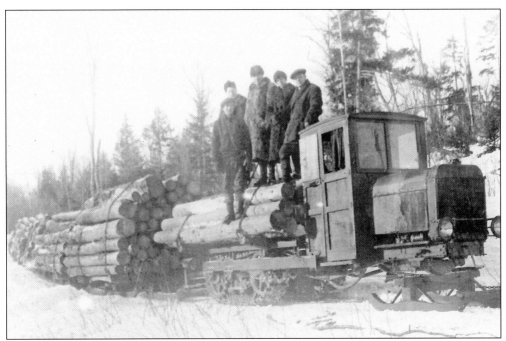

In 1924, Lewis County lumber baron G. H. P. Gould purchased the entire town of McKeever, including its two mills. The pulp mill operated on a 24-hour schedule and produced 50 tons of paper a day. During Gould's two-decade tenure, the Linn tractor shown here was introduced to operations in the North Woods. The last exciting spring river drive through McKeever occurred in 1948.

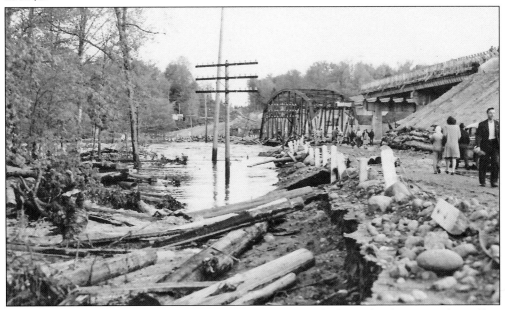

This 1947 photograph, taken after heavy spring rains washed out the dam near the mill at McKeever, shows construction of the new bridge over the state highway. Traffic was rerouted miles around through neighboring Lewis County to the Stillwater Road and then an additional 34 miles through Big Moose to Old Forge.

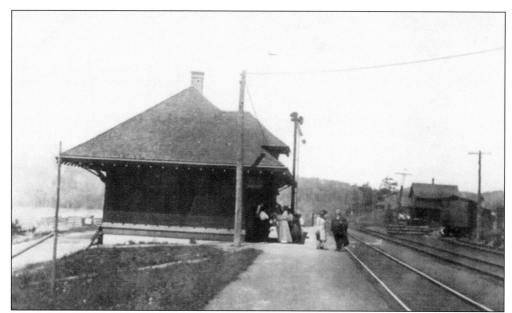

In 1950, the Rice Veneer Company took over the abandoned Gould mills at McKeever. The few remaining school-aged children were then bused to Old Forge. The company store in town was restocked with supplies for the 12 remaining households and 60 employees. The once busy depot, where 200 people jubilantly greeted John A. Dix in November 1911 to celebrate his gubernatorial election, is now a private residence.

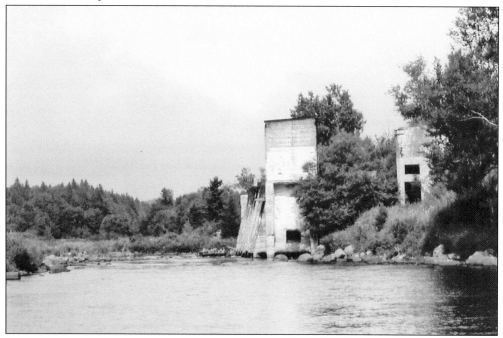

In August 1961, an auctioneer's hammer put a permanent end to McKeever mill operations. The factory, equipment, and 28 separate parcels were sold off in a single day. The former industrial center of paper and pulp production in the Central Adirondacks is today home to a handful of residents who enjoy the peaceful riverbank alongside the crumbling ruins of the old mill.

Three

FULTON CHAIN OF LAKES
FIRST LAKE TO FOURTH LAKE

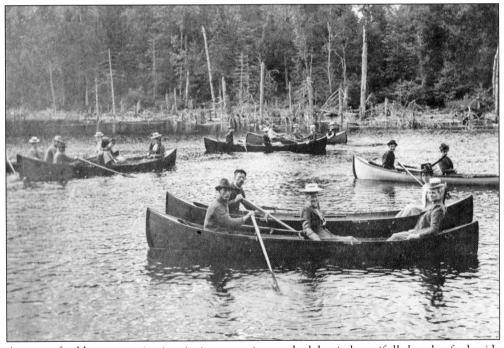

A group of wilderness tourists is enjoying an outing on the lakes in beautifully handcrafted guide boats. The guide, who not only piloted the boat backward, but also shouldered it over the carries from lake to lake, did all the work. This chapter explores the camps, hotels, and people who visited and lived along the first four lakes of the Fulton Chain, from Old Forge to Inlet.

Ned Ball built a camp on the channel to First Lake in the 1880s and was one of the most respected guides in Brown's Tract. "What he doesn't know about the Adirondacks and their wild inhabitants is not generally learned in a lifetime," wrote *Woods and Water* editor Harry V. Radford. This photograph of Ned, his daughter Eunice, and friend Maisie Soper was taken at the Ball homestead, still owned by his descendants.

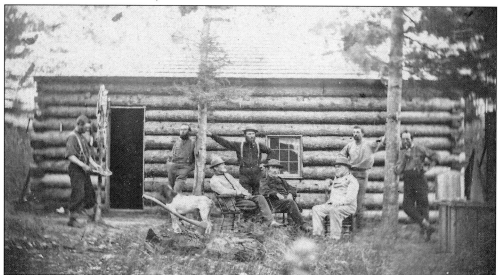

Benjamin Stickney, proprietor of a hotel in St. Louis, established this squatter's camp in 1866 on the peninsula between First and Second Lakes. Stickney's close friend Rev. Dr. Samuel Niccolls held outdoor Sunday services here for decades. The new cottage that James C. Pullman built for Dr. Niccolls in 1897 still stands on this historic site, known today as Morrow Point.

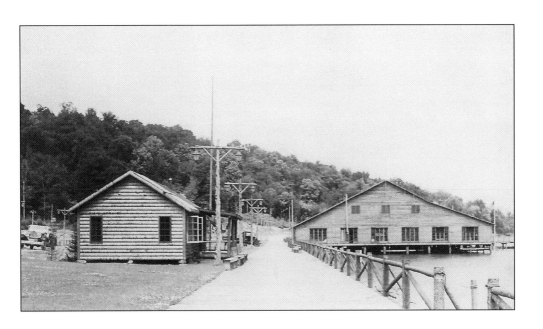

After a mudslide destroyed a Long Beach development in California and a hurricane in 1926 washed out homesites in Hollywood, Florida, Joseph W. Young brought his bulldozers to a new project called Hollywood in the Hills on First Lake. The steamer *Clearwater* was refurbished to bring thousands of prospective buyers to this sales office and canvas-topped casino (above). Nearly 1,400 tiny cottage sites that ranged from $600 to $1,200 per parcel were sold. Joseph Young died two months before the Hollywood Hills Hotel (below) opened with fanfare in June 1934. The Hollywood in the Hills development project floundered during the Great Depression without its charismatic leader. The massive log hotel was purchased by the Noonan family and converted to condominiums in 1978. A handful of vintage 1930s cottages still dot the landscape.

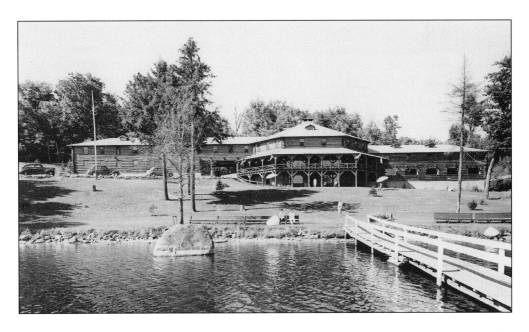

Samuel Dodd had this cottage built on First Lake on what is today called Fletcher Point. George Goodsell of Old Forge constructed it. Dodd later relocated to a new camp at Little Moose Lake on a promontory called St. Louis Point for the enclave of Adirondack League Club members who hailed from that Midwestern city.

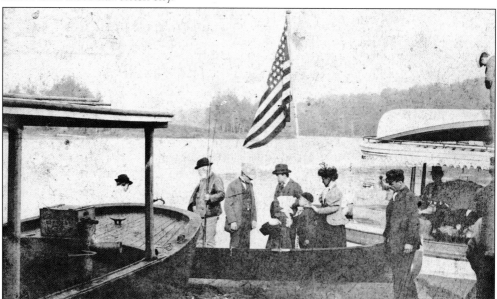

Pres. Benjamin Harrison spent the summer of 1892 in the Adirondacks with his wife, Caroline, hoping she would recover from tuberculosis. Caroline died in the White House that fall shortly before Harrison lost his bid for reelection. He returned to the Adirondacks to spend the summer of 1895 at Dodd's camp on First Lake. Harrison, sporting the white beard, is shown at the dock with his daughter, Mary McKee, and her two children.

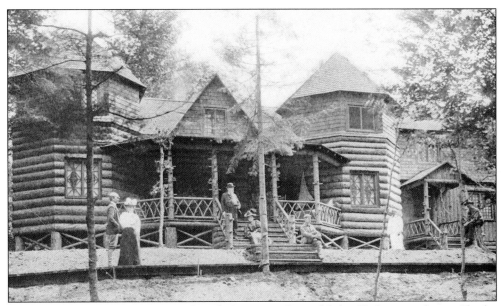

During his 1895 visit, Harrison purchased 10 acres on Second Lake. Herkimer architect Charles E. Cronk designed his artistic summer cottage. The former president married his late wife's niece, Mary Lord Dimmick, in April 1896. The newlyweds came to Second Lake that summer. The lodge provided a retreat away from the pressures of his law practice and diplomatic affairs. It was named Berkeley Lodge after his grandfather William Henry Harrison's ancestral plantation in Virginia.

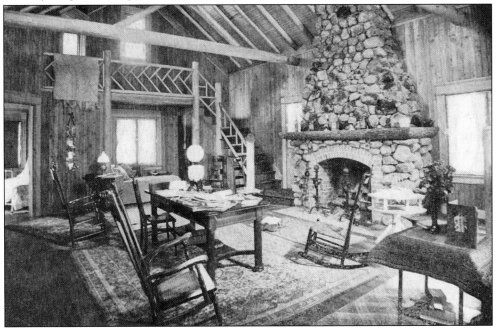

The Berkeley Lodge guest book's first entry in July 1896, written in President Harrison's own hand, reads, "Arrived after an arduous journey from Indianapolis to find windows and doors unhung and wood shavings throughout; someone sat down on the front steps and cried." After Harrison's death in 1901, Mary and their daughter Elizabeth returned to Second Lake for the next decade and maintained ties to the region for many years.

Mailboat service was established on the Fulton Chain in 1901 due to the influence of President Harrison and Dr. William Seward Webb and continues to this day. The toot of the boat's horn brought hotel staff and camp residents to their docks to exchange leather or canvas pouches with the boat's mail clerk. On the deck of this first mailboat are, from left to right, pilot Burt Youmans, engineer Chauncey Covey, and mail clerk Curley Erwin.

The "pickle boat" referred to several grocery boats plying the Fulton Chain. Always greatly anticipated, the arrival of the pickle boat was greeted by children, adults, and hotel staffs at their docks. Stocked with groceries, fresh produce, meat, milk, candy, postcards, and souvenirs, the floating store was a treat for all. Walter Marks and Charles Wilcox of Old Forge operated the best-remembered pickle boat from 1905 to 1941.

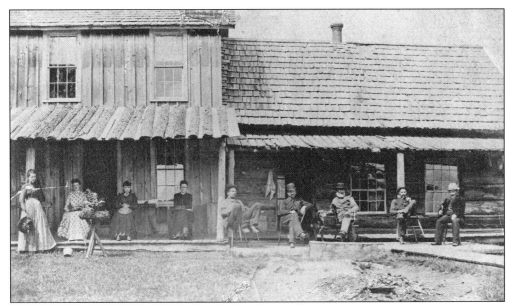

Charles Grant of Boonville, an early surveyor and guide along the Fulton Chain, erected a rustic log camp on Third Lake. Sam Dunakin, one of the region's most famous guides, assisted him. In April 1868, Grant was overcome with fatigue and tragically froze to death along the old Brown's Tract Road. Robert Perrie purchased Grant's camp and added the two-story addition shown here.

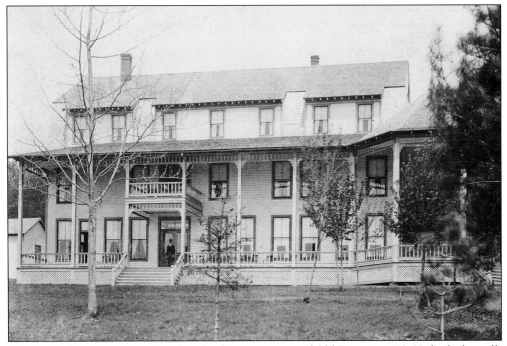

Charles M. Barrett was appointed as the first postmaster of Old Forge in 1883. He built the well-known Bald Mountain House in 1893 on the former Grant-Perrie Third Lake property. Earl Barrett became the proprietor after Charles's death in 1930. The Barrett family, still owners of property on this Third Lake site, operated the grand old hotel until the tent-and-trailer blue-jeaned crowds in the 1960s led to its demolition.

The most popular hike in the Old Forge area is the mile long trail to the fire tower on Bald Mountain. Samuel Dodd's family christened it Mount St. Louis, a name that appeared on state surveyor Verplanck Colvin's sketches and maps from the late 19th century. This vintage photograph shows the Nitzschke family on the section of the hike known as the "hogsback."

This enormous erratic called the Balancing Rock on Bald Mountain has weathered the test of time for centuries. In the 1940s, several youths used dynamite and tried unsuccessfully to send it cascading to the valley floor below. Weddings have taken place on top of Bald Mountain, and according to the trail registers, many couples have exchanged marriage proposals here too.

Harriet Rega moved to Old Forge in the early 1920s for her health. She pursued a trapping career before accepting a position as the state's first female fire tower summit steward on Mount Electra at Nehasane Park. In 1929, Rega transferred to Bald Mountain, where she remained for the next six years. The 1917 steel tower, closed in 1990, was restored by volunteers and reopened to the pubic in 2005.

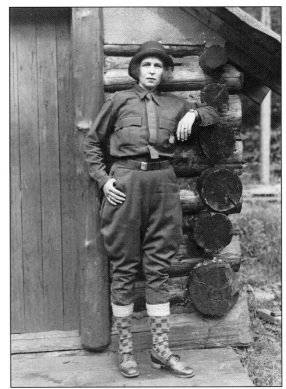

Bald Mountain, also called Rondaxe Mountain by the state, is 2,350 feet above sea level. This young woman scaled the trail to the top without difficulty in her spectator pumps. Panoramic views of First and Second Lakes include Stickney, now Morrow Point, in front of deCamp Island as well as little Dog Island in the distance between Panther and Little Moose Mountains.

Lottie E. Tuttle (above) was the first licensed female guide in New York State. She and her husband, Orley Tuttle, operated Bay View Hotel on Fourth Lake from 1908 to 1918. Lottie was an accomplished markswoman, artist, writer, elocutionist, and taxidermist. Orley loved fishing and fashioned lures called "Devil Bugs" made with deer hair after he observed bass were attracted to fuzzy beetles. The Devil Bugs met with immediate success. In 1922, there were 50,000 lures sold nationwide, due in part to Lottie's beautifully illustrated marketing brochures. Their children—Fern, Elton, and Edith (pictured at left with her father, Orley)—all made Devil Bugs. Edith also became a licensed guide and was a lifelong active fisherwoman. Shortly before her death in 2004, Edith celebrated her 101st birthday with her many friends on the Fulton Chain.

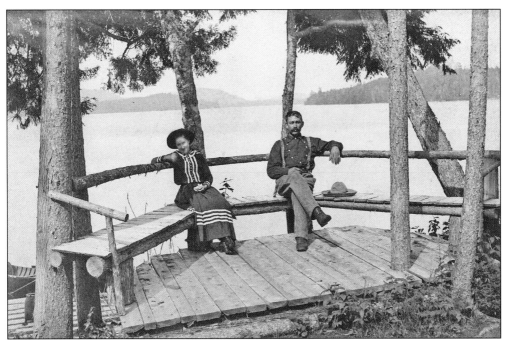

Relaxing was a rare thing for pioneer couple George and Jennie Goodsell (above). In the early 1890s, they bought property on a peninsula between Third and Fourth Lakes where George built the family's first home (below). In addition to guiding, George was an excellent carpenter and became one of the most sought after contractors in the region. In the spring of 1900, they moved to a new home George built that winter on Main Street in Old Forge. When Old Forge incorporated as a village in 1903, George was elected as the first president. Sadly, Jennie's health was fragile and she died of pneumonia in 1908, leaving her husband to raise their four young children.

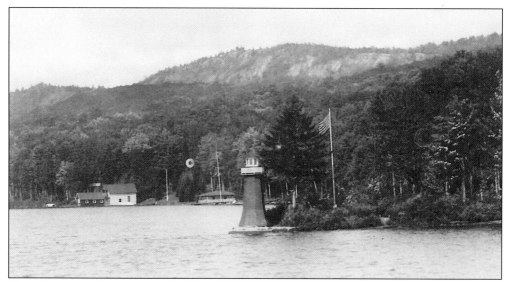

Shoal Point extends from the North Shore of Fourth Lake. George F. Raymond of Brooklyn built the lighthouse in the 1890s, and it has always been privately operated and maintained. The Fourth Lake Property Owners Association recently undertook a complete restoration of the lighthouse and holds a long-term lease on the property. Since 2001, the light has once again been turned on every evening throughout the summer.

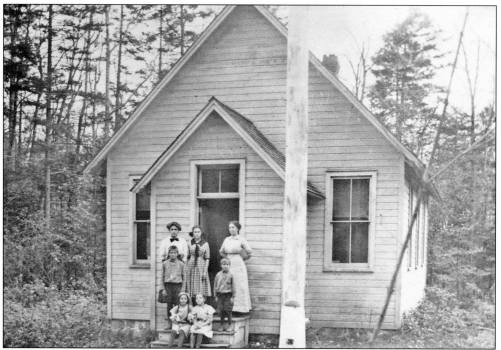

The one-room Minnowbrook schoolhouse on Fourth Lake was built by George Cyrus Burnap in 1905 and operated until 1926. Grades one through eight were taught in the 20-foot-by-30-foot building. Anita, Marion, Don, and Ken Burnap appear in this 1912 photograph with their teacher Miss Bergholz. Fern and Edie Tuttle, sitting on the steps, came by boat or snowshoed across the lake during the winter months.

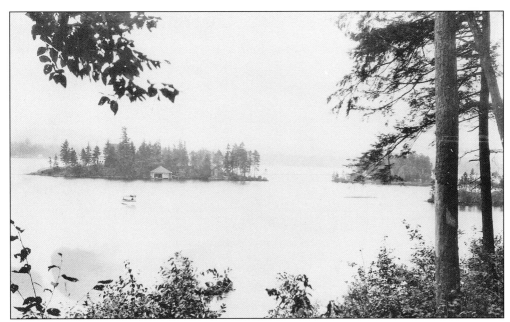

Dr. John M. Barton, from Rome, launched a houseboat on the Fulton Chain in 1894 that was built by Theodore Seeber and Ira and Ben Parsons of Old Forge. Tired of nomadic life, Dr. Barton purchased the large upper Twin Island on Fourth Lake in 1901. Real estate developer William Thistlethwaite reserved the smaller island behind the trees for his own summer cottage, designed by architect Charles. E. Cronk of Herkimer.

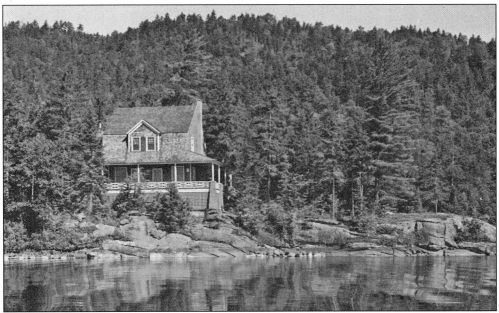

Local contractor William A. Goodell had this summer cottage ready for Dr. Barton in 1902. Supplies came from the Garmon and Salmon mill on Third Lake. Barton's new naphtha launch *Polyanthus* transported the family and supplies back and forth to the island. Subsequent property owners have been wonderful stewards of the Barton and Thistle Island cottages that remain relatively unchanged today.

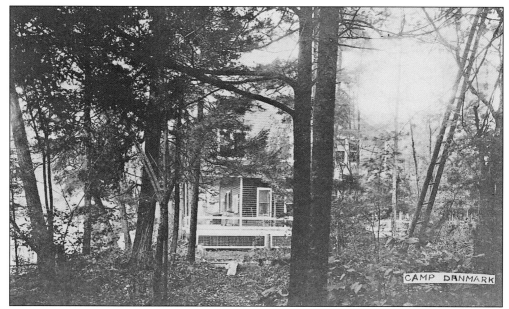

While vacationing at the Mohawk Hotel in 1905, Danish American immigrants Karl and Metthea Mathiasen negotiated the purchase of this lovely point on the South Shore of Fourth Lake. The Mathiasens named it Camp Danmark and expanded the facilities over the years to accommodate their large family and many friends. In 2005, more than 100 descendants gathered to celebrate the 100th anniversary of the family's ownership of the camp.

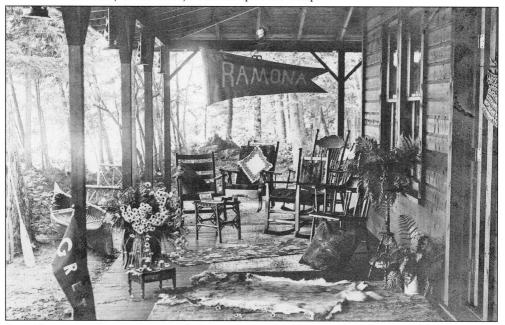

Rose Harrer was the proprietor of the Ramona Hotel and cottages on Fourth Lake for 30 years. Affectionately known as Aunt Rose by her loyal patrons, she was married to veteran guide Christian Goodsell from 1913 until his death in 1919. Ramona Point Road on the North Shore provides access to her property today, although the charming hotel was put up for auction in 1974 and torn down.

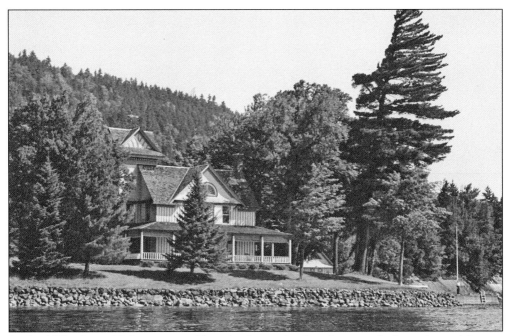

In the 1870s, Lewis H. Lawrence, a Utica lumber and railroad tycoon, built a substantial camp on a beautiful promontory on the North Shore of Fourth Lake. It has been known ever since as Lawrence Point. Lawrence, an avid outdoorsman, built other camps at Moss and Limekiln Lakes and enjoyed his expansive domains until his death in June 1905. His descendants continue to own property on Lawrence Point.

Emil Murer established a hotel in 1891 at a busy spot on Fourth Lake where steamboat travelers disembarked to begin the carry trail to Big Moose Lake. Fred and Ida Becker of Altamont, New York, owned the property from 1903 to 1934 and then sold it to their daughter Freida and her husband, Leo Westfall. The Westfall twins, Constance (left) and Ann, are shown with their nurse on the walkway to the Becker's Hotel waterfront.

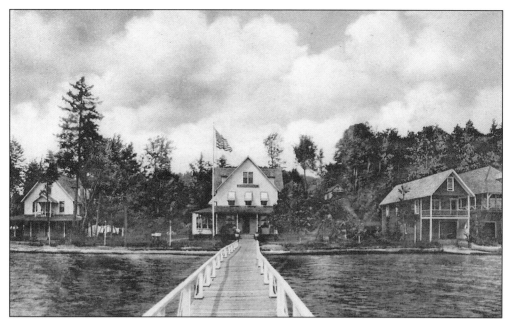

Anna Freeman, wife of Jay D. Freeman of Utica, opened the Kenmore on Fourth Lake in 1899. Oswald Schoelz owned the resort from the 1920s to 1953 and called it the New Kenmore. He sold it to the Richard McCarley family for $35,000. The main lodge and boathouse burned to the ground in 1965 while under their proprietorship, but the cottages continue to attract guests devoted to this part of Fourth Lake.

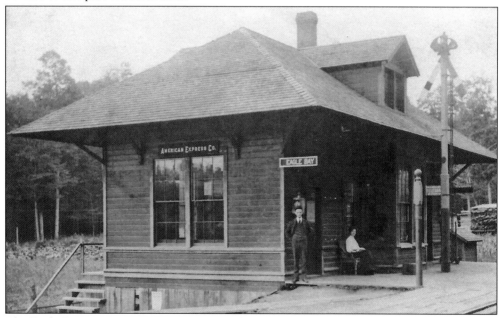

The Eagle Bay station was a major stop on the 19-mile Raquette Lake Railway. Mohawk and Malone Railroad passengers made connections at Carter to this station or flag stops at hotels along Fourth Lake. After leaving Eagle Bay, the tracks continued on to Raquette Lake, where Collis P. Huntington, J. P. Morgan, Alfred Gwynn Vanderbilt, and other wealthy capitalists maintained elaborate Adirondack-style camps.

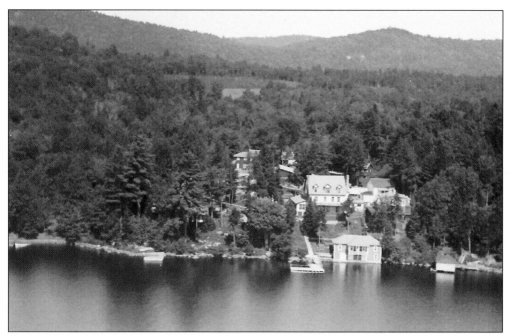

Around 1905, Frank and Delia Lee and their daughter Alice built a substantial hotel and cottage colony near Eagle Bay called the Cliff House. Claude Hoagland bought the hotel in the late 1930s. Hoagland, a New York City orchestra leader, had fallen in love with the Adirondacks when he was playing a gig at another Fourth Lake hotel. In 1959, the property was subdivided and auctioned for private camps.

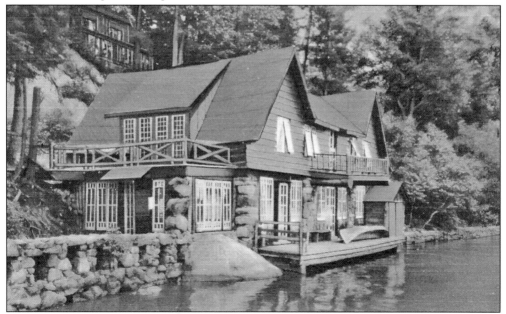

Ledgedale Lodge owners claimed its site to be the highest point on Fourth Lake at just over 1,800 feet above sea level. Operated as a hotel by the McMahon and Sheedy families from the late 1800s until the early 1950s, the hotel was renowned for its fine cuisine. This boathouse is one of several romantic buildings on the property that are now private camps.

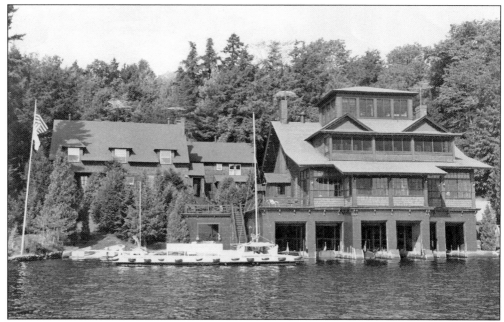

O. M. Edwards, a Syracuse industrialist, built this summer retreat in 1909. Edwards named it Paownyc because of his association with the Pennsylvania, Ohio Western, and New York Central Railroad Companies. Additional residences were carved out of the hillside for each of his daughters and their families. These beautifully maintained rustic arts-and-crafts-style buildings are happily enjoyed by more than 150 descendants today.

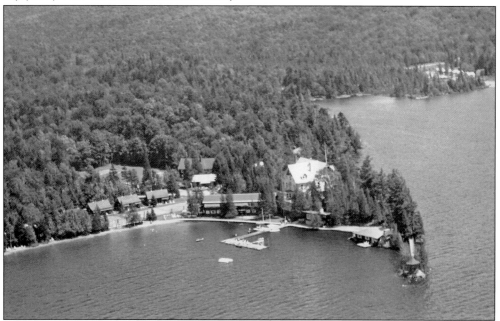

Situated on this Fourth Lake promontory, Rocky Point Inn opened in 1892. It grew in size, style, and reputation longer than most other resort hotels on the Fulton Chain. Accommodations included meals, a beautiful bathing beach, tennis, and boating. Three generations of the Delmarsh family owned the hotel until it closed in 1987 to make way for lakeside condominiums.

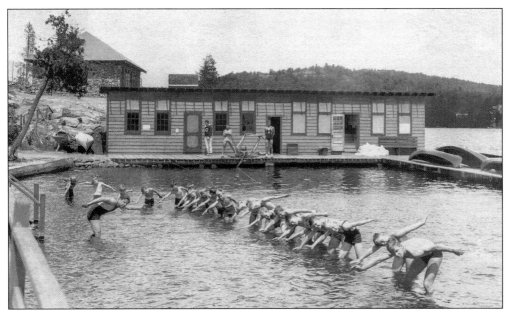

Fred Hess built a small retreat on Cedar Island in 1871. For the next four decades it operated as a rustic hostelry under various owners. In 1915, the main camp burned and reopened the following year as the Cedar Island Camp for Girls. In 1925, it became Ten-Rab, also a girls' camp. Dr. George Longstaff started Camp Cedar Isles for Boys in 1934. Since it was situated on three islands, water sports were the highest priority. Before boys could learn to sail, they had to be accomplished swimmers. For many years the campers averaged 2,000 miles under sail each season. The camp continued operating into the 1950s, when the property was sold and converted to a private residence.

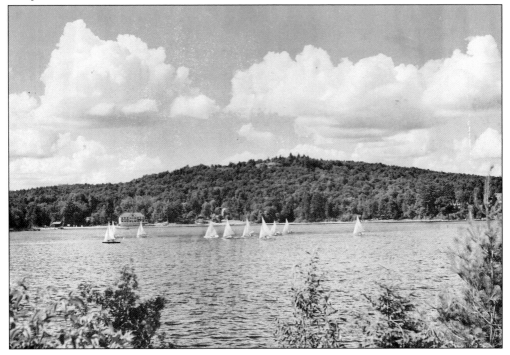

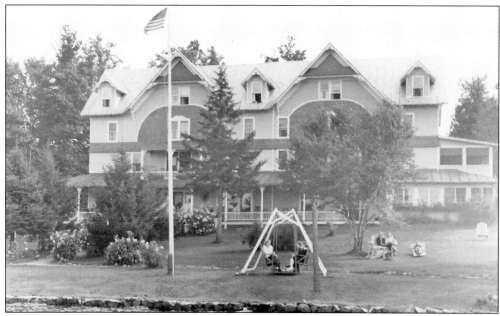

The Neodak opened near the head of Fourth Lake in 1902 under the management of William A. Preston. Emma and Roy W. Rogers owned the property when the original hotel burned in November 1919. The New Neodak continued with great party traditions encouraged by the enthusiastic proprietors. William and Emma's son John sold the property to auctioneer Charles Vosburgh in 1958.

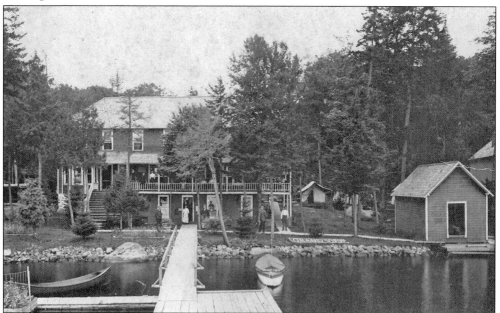

In 1902, John J. Rarick completed construction of the Grand View along the South Shore of Fourth Lake. Rarick sold to a New York City firm in 1920 that opened the first of several children's sleep-away camps at this location. The first was Lo-Na-Wo for girls, followed by Kee-Yo-No for boys. Caroline Longstaff named it Camp Eagle Cove in the 1930s. The property has since been subdivided for private homes.

Anneliese von Oettingen taught ballet to campers at Moss Lake Camp for Girls before starting her own coed ballet school in 1973 at Eagle Bay. Until her death in December 2002, Anneliese filled her summer camp with young balletomanes from all over the world. One fabled camper, Suzanne Farrell, became a prima ballerina with the New York City Ballet and a longtime summer resident on the Fulton Chain.

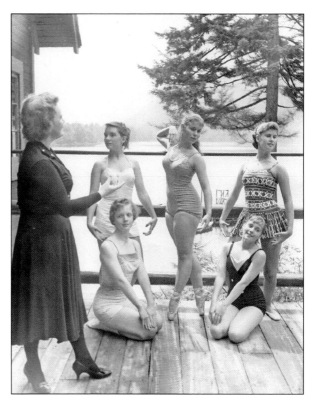

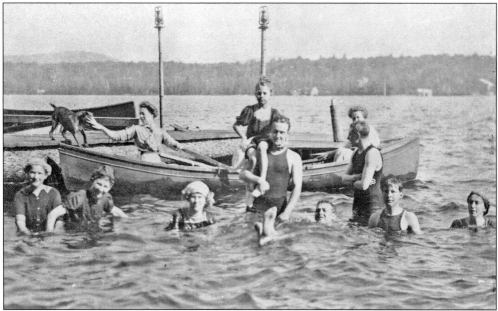

Swimming across the lakes in the Fulton Chain was a rite of passage. In the 1920s, swimming competitions between children's camp counselors and hotel employees were frequent and included races from Inlet to Old Forge. Most swimming, however, was less strenuous and more playful. It was quite common to use the lakes for washing oneself, as bathtubs were still a luxury at many camps and hotels.

Memories are made of this. Family vacations were a ritual that included exciting train and steamboat trips in order to reach the Fulton Chain, followed by fresh air and wonderful summer activities. These children on a dock in 1905 likely recalled their summers at the lake for years and relived their experiences at subsequent lakeside family reunions. Scrapbooks are full of treasured photographs like this one of someone's grandparents or great-grandparents as children. Although traveling to the Fulton Chain is less arduous today, fond memories are still being created and shared around campfires on romantic moonlit nights or while watching spectacular sunsets over the lakes.

Four

FULTON CHAIN OF LAKES
FIFTH LAKE TO EIGHTH LAKE

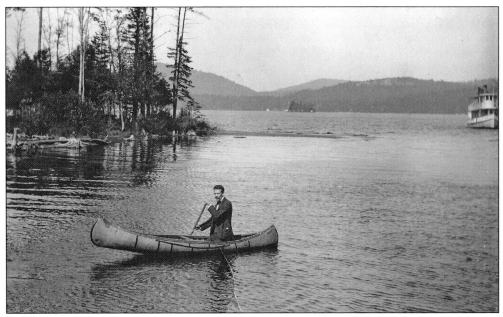

Paddling a birchbark canoe into the channel at the head of Fourth Lake is veteran guide and taxidermist Artemus M. Church. Although Artemus made his home in Boonville, he owned property on Fourth Lake and kept a sportsmen's camp on Seventh Lake during the 1890s. The photographs in this chapter begin at Inlet and explore sites leading to the headwaters of the Fulton Chain at Eighth Lake.

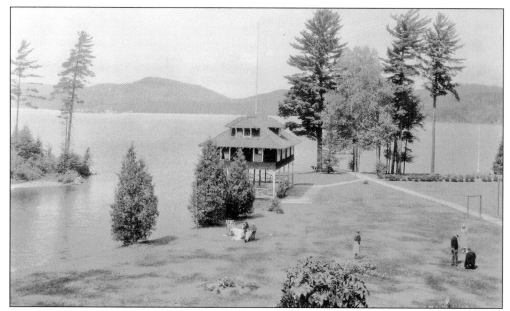

James Galvin of Carthage and several partners formed the Fulton Chain Club and purchased 6,000 acres encompassing a triangular tract from the Fourth Lake shoreline to Seventh Lake down to Limekiln Lake. In 1890, they sold a large parcel to Fred Hess. Visitors in August 1891 noted that Hess was building a hostelry near the inlet at the head of Fourth Lake similar to Charles Bennett's Antlers Camp on Raquette Lake.

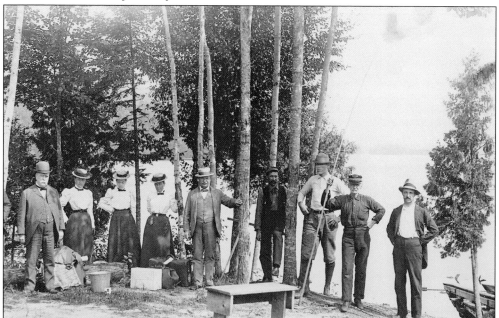

Fred Hess erected a sawmill near Fifth Lake in 1891 to provide lumber for Galvin's club, workers' camps, and his hotel, which included 24 sleeping rooms by 1893. His wife, Ellen, managed the hostelry and provided hearty fish and venison meals. Stage and steamer services offered shoreline picnic excursions to the upper Fulton Chain lakes. Fred Brown, identified here on the right with suspenders, was a guide for these day-trippers.

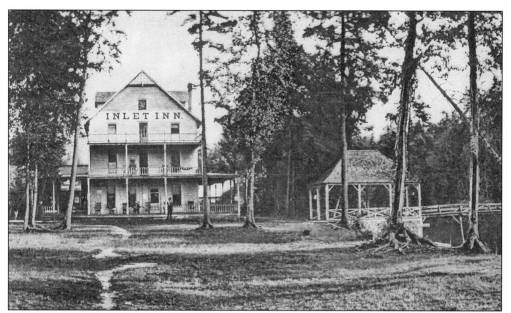

Charles O'Hara's Inlet Inn was built in 1897 just up the Fifth Lake channel from Fred Hess's hotel that was consumed by fire the previous year. O'Hara, formerly a barber and store operator, was appointed as the first postmaster of Inlet in 1898. The Town of Inlet separated from the Town of Morehouse in November 1901. The new town board held its first meeting in January 1902 at the Inlet Inn.

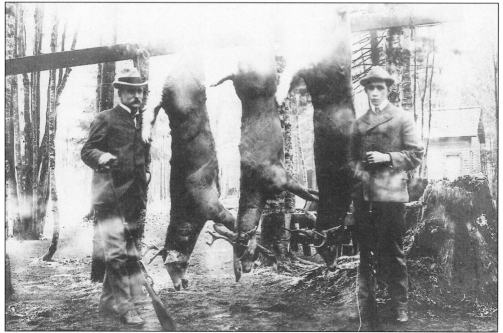

The thick forests surrounding Inlet attracted many sportsmen, including George F. Delmarsh (left). Delmarsh, a Civil War veteran, served as the postmaster of Inlet from 1900 to 1909. He and his wife, Mary VanArnum Delmarsh, were the parents of a daughter, Katherine, and Inlet area guides and hotelmen, Arch and Eri.

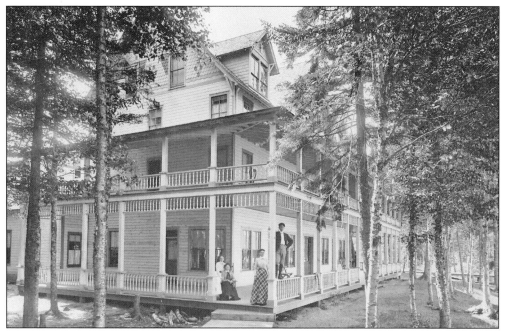

The Moshier brothers assumed Fred Hess's mortgage and rebuilt the hotel in 1897. Renamed the Arrowhead, it too succumbed to fire in 1913. Charles O'Hara erected the New Arrowhead in 1916. The Town of Inlet acquired the hotel and cottages in 1963 from O'Hara's descendants. Voters approved a $128,000 bond issue to create Arrowhead Park for a public beach, parking lot, town hall, tennis courts, and playground.

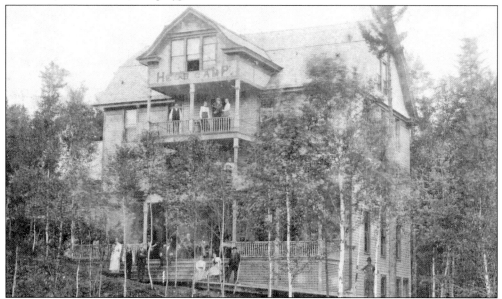

Before leaving for the Maine woods, where he died in 1925, Fred Hess erected another Hess Camp in 1898. It was later acquired by veteran hotelman Philo C. Wood, who was the proprietor of the Wood Hotel for nearly 40 years. In 2003, Joetta McClain and Jay Latterman bought the dilapidated structure and undertook extensive restorations. The Woods Inn operates in the same grand style as it did a century ago.

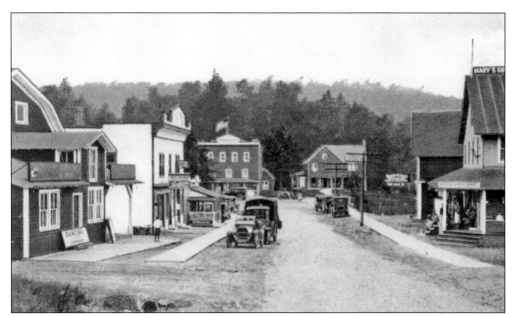

The Fulton Chain Club sold additional lots to Inlet's pioneer families for homes and businesses to serve the tourist trade. Pictured here in the 1920s are, from left to right, Thomson's Pavilion theater and dance hall, supervisor Frank Tiffany's real estate office in Roustone's Gayety building, and Fred Parquet's rooms and restaurant at the end of the street. On the right are Harry Hall's grocery store and Dan and Mary Decker's gift shop.

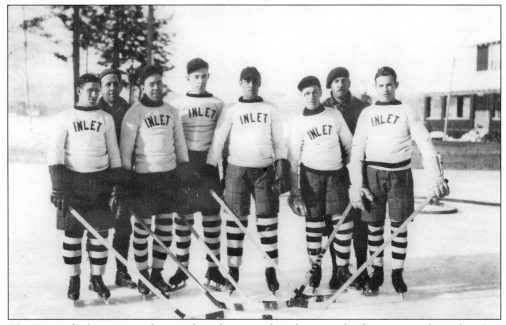

The Town of Inlet sponsored an outdoor skating rink and semipro hockey team in the early 1930s. The rink was located at the top of the hill leading into town near a 30-foot-high toboggan slide over the state highway. The slide provided exhilarating rides out onto Fourth Lake. Len Harwood, Lansing Tiffany, and Edward Youmans served as officials for the predominately French Canadian members of the team.

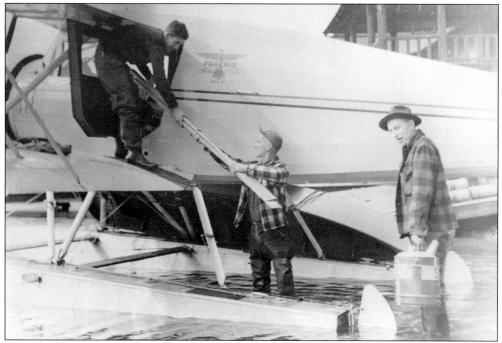

Al Brussel and Harold Van Auken established sightseeing floatplane excursions on Fourth Lake in 1929. Merrill Phoenix, one of their first pilots, often kept his own plane near the Wood Hotel. Expert pilots delivered sportsmen to remote camps, spotted forest fires, and rescued the lost and injured. Shown here loading Phoenix's plane with trout fingerlings to stock the lakes are, from left to right, Jack Kelly, Leo Minnie, and Robert Goodsell.

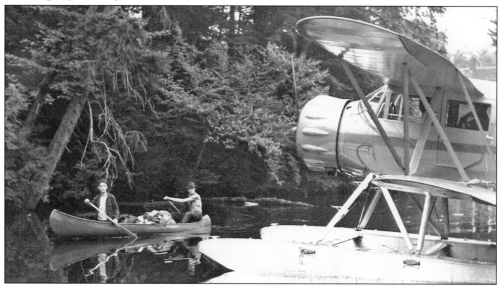

Harold "Scotty" Scott, married to Dorothy McIntyre of Dolgeville, was an Inlet pilot and tavern owner. They moved to Inlet in 1930 and Scotty began taking passengers for rides in a floatplane he parked behind his home on the Fifth Lake channel. Scotty was known for his dynamic personality and superb knowledge of the Adirondack topography. He was frequently accompanied by his best pal, "Boots," a Boston terrier.

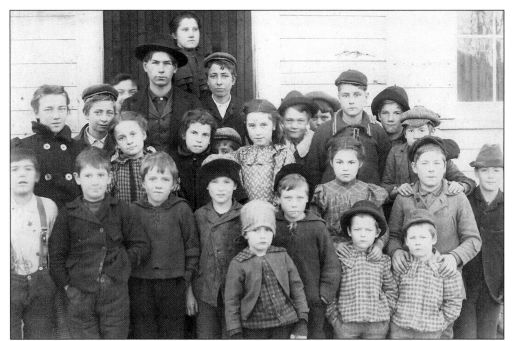

This group of students attended the Inlet Common School, which was built on land acquired from the Fulton Chain Club in 1901 along Fifth Lake. It still stands adjacent to the new, larger schoolhouse that was erected in 1910 to accommodate Inlet's growing population. Primary grades continue to attend classes in the 1910 school building, while upper grades are bused to Old Forge.

A narrow channel from Fourth Lake leads to the pretty little Fifth Lake. At the head of the lake is the "take out" for the canoe carry that follows a stream to the dam at Sixth Lake. John O'Hara of Glenfield built a wagon road from the railroad station at Eagle Bay to Sixth Lake in 1903. The paved highway through Inlet to Raquette Lake was completed in 1929.

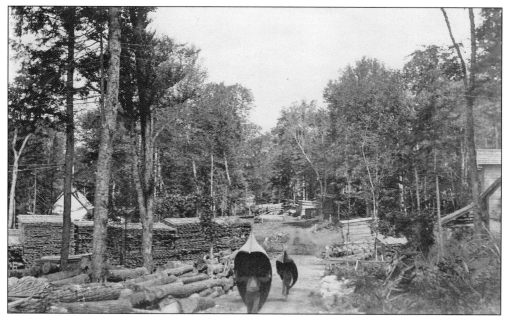

Guides, portaging their boats in the traditional manner along the carry road between Fifth and Sixth Lakes, pass by stacks of lumber (above) cut at the sawmill (below) built by Fred Hess. The boards were used to construct most of the camps and hotels along this part of the Fulton Chain. Stories about Hess, considered the "Father of Inlet" today, are legendary. He could carry two 150-pound deer on his shoulders over a mountain and once skinned a wolf with a safety pin. Hess much preferred guiding guests on hunting and fishing trips to running his hotels. Financially strapped and unable to pay the mortgages on properties he bought from the Fulton Chain Club, Hess was forced to sell the sawmill in 1895.

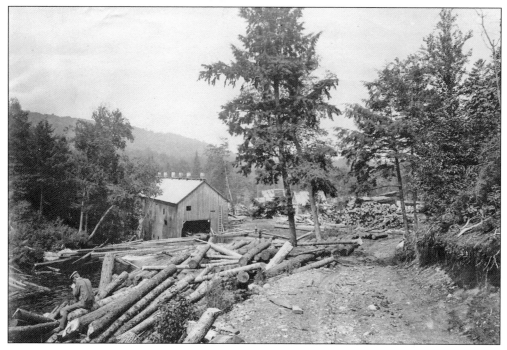

After diverting the Black River for the benefit of the Erie Canal, the state took control of the dam at Old Forge in 1880 and erected a dam at Sixth Lake. The Moose River, a tributary of the Black River, provided a reservoir of water for mill owners along the route to Watertown. Sixth and Seventh Lakes were turned into "graveyards for forests," according to a writer in 1883.

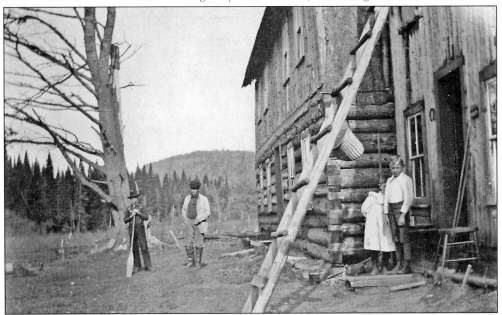

The headwaters of the South Branch of the Moose River begin deep in the Moose River Plains. In the early 1890s, Wellington (second from left) and Eliza Kenwell arrived in the plains on foot from North Creek and built this farmhouse-type sportsmen's camp that accommodated 30 guests. The Kenwell family, including their two children, Laura and Gerald (standing together at right), stayed for 10 years even though the closest access to the remote camp was over a primitive 11-mile trail near Sixth Lake.

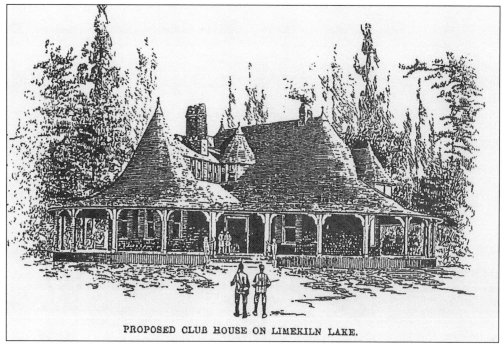

PROPOSED CLUB HOUSE ON LIMEKILN LAKE.

The 1891 prospectus for the Fulton Chain Club included plans for this elegant lodge at Limekiln Lake. The club failed to sell most of the $500 shares to 120 proposed members, and the lodge was never built. Except for the eastern shoreline, Limekiln Lake was lumbered by the Gould Paper Company and sold to the state for a public campground that opened in 1963. (Courtesy of Adirondack Museum, Blue Mountain Lake, New York.)

Two privately owned hotels were built on the pine-clad eastern shore of Limekiln Lake. Shown here is the Limekiln Lake Hotel erected by Walter Darling in 1921. Soon after, Eri Delmarsh put up the Delmarsh Inn, later known as Holley Inn. Today a 3-mile road near Sixth Lake leads to the sandy shore and cottages along the private portion of Limekiln Lake.

Gerald Kenwell and his wife, Ina, established the Sixth Lake Inn, complete with a marina and store. Like his father Wellington, Gerald was a superb guide and hotelman. Kenwell's store was also headquarters for his boat route that plied the waters of Sixth and Seventh Lakes delivering passengers, freight, and groceries to the waterside hotels and camps. In the 1930s, Ben Snyder built the 50-foot-long *Osprey*, pictured below, for Kenwell. It had the capacity to hold 75 people. Gerald hosted many chartered groups for hotel-catered steak cookouts called "shore dinners." In 1942, Norton "Buster" Bird purchased Kenwell's holdings, including the *Osprey*, which was later sold to the Enchanted Forest and converted to a pirate ship. Bird's seaplane business operated from Sixth Lake for more than 50 years.

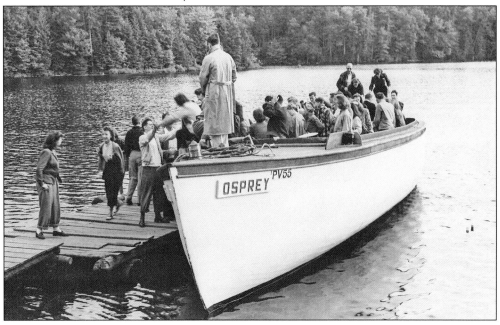

The northerly view above of Sixth Lake shows Black Bear Mountain in the distance, one of the most popular hikes on the upper Fulton Chain. Two trails, one from the Uncas Road and another from the campground at Eighth Lake, lead to the 2,454-foot-high summit. The bridge below divides Sixth and Seventh Lakes and provides access to privately owned camps along their northern shorelines. An association of Sixth and Seventh Lakes property owners formed in 1939, and members have removed many of the dead trees and stumps caused by flooding when the dam was built. Today there is a scenic turnout along the state highway overlooking peaceful Seventh Lake.

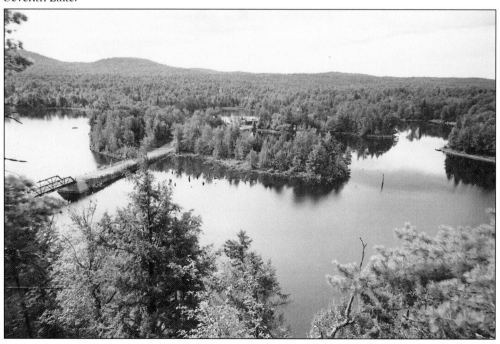

Duane Norton built the Seventh Lake House in 1898 on the North Shore of the lake. He sold the hotel to Charles Williams of Big Moose in 1903 for a princely sum of $7,000. The family of Charles Williams, including his brother Frank, the Breens, and the Pitt Smiths, added cottages and operated the resort for half a century. The hotel was torn down after the entire property was sold at auction in August 1956.

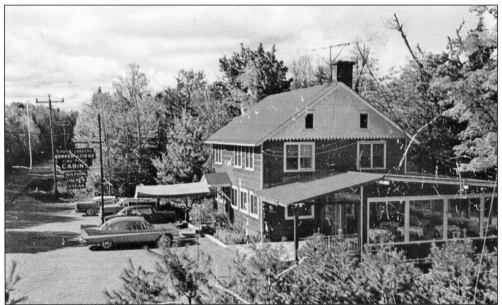

Charles Landers, the original owner of Beaver Lodge on the South Shore of Seventh Lake, rented out fishing shacks during the winter hoping customers would come in for invigorating beverages. Patrons oddly began nailing shoes to the ceiling, a tradition continued by the next owner, James Masters. Proprietor John Frey renamed the tavern the Seventh Lake House. The Holt family currently owns the landmark restaurant—sans shoes.

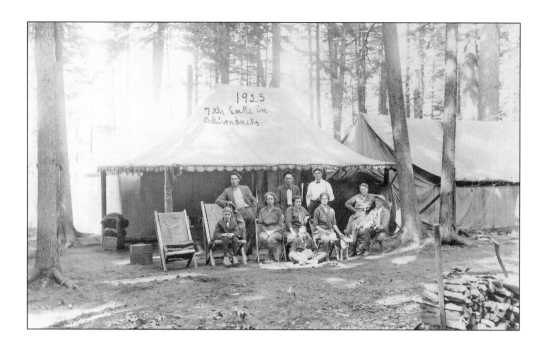

Oma V. Glazier donated a group of charming photographs to the Town of Webb Historical Association in 1986, including several of the Ernest Parsons tent camp on Seventh Lake. Her husband was a friend of Parsons, who came from the Canandaigua area. Several individuals in both photographs appear to be dressed in scouts or nurses uniforms. Seventh Lake hosted a number of youth camps, including Camp Syracuse for scouts in the 1920s before it relocated to Brown Tract Ponds. Just beyond the Seventh Lake House, Dr. Frederick O. E. Raab established another youth camp in 1926 known as O-Kwa-Ri-Ga. He was the principal of a trade school for boys in Rochester and died at his camp many years later in 1967.

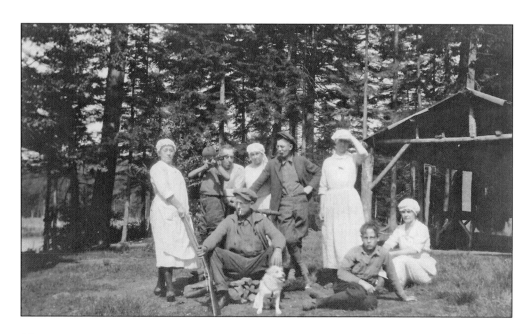

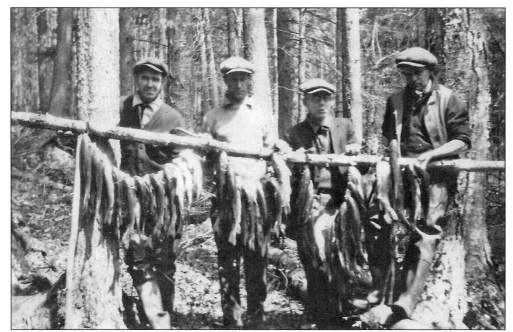

Rex Fisher of Bristol (left) and his brother-in-law Carl Simmons (second from left) of Canandaigua are shown here with two unidentified friends proudly displaying the fish they caught at Seventh Lake. In the early 19th century, rustic camps were built on Seventh Lake by trapper Green White and then by Edwin Arnold, who had an insatiable appetite for fish. Arnold's Point, on the state-owned portion of the North Shore, commemorates his ties to the lake.

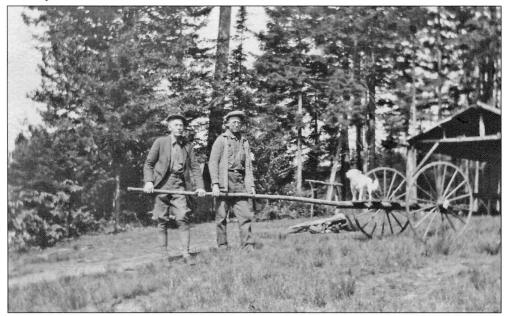

The mile-long carry between Seventh and Eighth Lakes, called a portage in other parts of the country, is familiar today to all who have paddled the "90-Miler" Adirondack Canoe Classic that begins in Old Forge and ends three days later in Saranac Lake. These two sportsmen from Parsons's camp on Seventh Lake are giving their pooch a free ride across the carry on their canoe cart.

It is the ladies' turn to pamper the pooch with a bath at Eighth Lake. The most famous resident of Eighth Lake was Alvah Dunning, a hook-nosed 19th century hermit and philosopher who lived in a squatter's camp on the island. Fulton Chain guides were somewhat fearful of Dunning's irascible personality, yet charmed by his spellbinding tales. To his dying day in 1902, when his obituary was carried nationwide, Dunning insisted the world was as flat as a pancake. Camouflaged in the photograph below is a Victorian lady at the Brown's Tract landing that marks the dividing line between Eighth Lake and the watershed that leads northward to Raquette Lake and the tributaries of the St. Lawrence River. The popular Eighth Lake state campground was created by CCC workers and opened in 1935.

Five

THE MOOSE RIVER
NORTH AND SOUTH BRANCHES

This chapter begins along the route of the North Branch of the Moose River from its headwaters at Big Moose Lake to Old Forge and then journeys through the Adirondack League Club on the South Branch. Both regions are historically linked economically and through family ties to the pioneer settlement of Old Forge. This peaceful setting is at the outlet of Big Moose Lake.

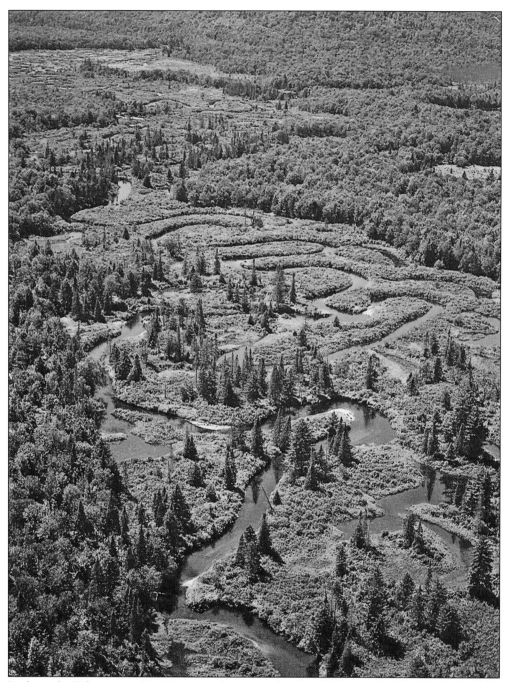

In the early 19th century, Big Moose was known as the Third Lake on the North Branch of the Moose River, Dart's Lake was called Second Lake, and Rondaxe Lake was the First Lake. Credit for the first hunting camp and a permanent name for Big Moose Lake is given to four Lewis County brothers: William, John, James, and Stevenson Constable. Legend has it they left the horns of a moose in a tree near the northwest corner of the lake, becoming the calling card for future explorers. Bill Weedmark, who owned a studio in Old Forge for more than 50 years, took this aerial photograph of the North Branch of the Moose River.

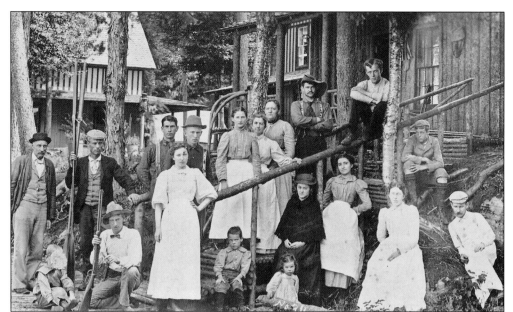

Several first families to operate hostelries in the Big Moose area are gathered here for a photograph at the Higby Camp. James Higby is on the far left. Gertrude Ainsworth is in the center, and Edward J. Martin, with arms folded and wearing a wide-brimmed hat, stands on the steps. Big Moose Lake has many century-old rustic Adirondack dwellings, including a few with palisade-style spruce-bark siding like the former Higby Camp.

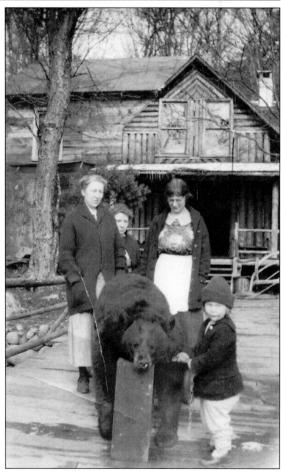

The Waldheim, Hattie and E. J. Martin's resort on Big Moose Lake, opened in 1904 with five guest bedrooms. German for "home in the woods," it is owned and operated today by their descendants. Hattie rose very early to do the baking and tend to guests, while E. J. expanded the resort and built other camps on the lake. She is pictured here to the left of the bear, and her young son Howard is to the right. This bear may have been trying to raid Hattie's kitchen.

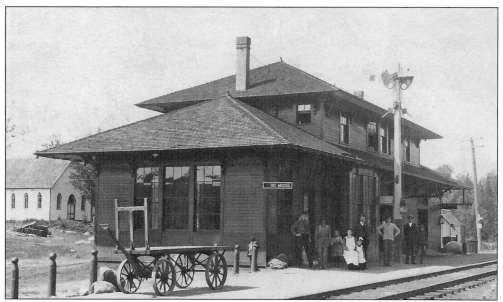

The growth of Big Moose soared after Dr. William Seward Webb decided to make it a station stop on the Mohawk and Malone Railroad in 1892. On April 26, 1923, fire destroyed this depot. New York Central Railroad employees fought the blaze but were only able to save a few records and the safe. Holy Rosary Church, in the background, was dedicated in 1899 and built with donations from area lumberjacks.

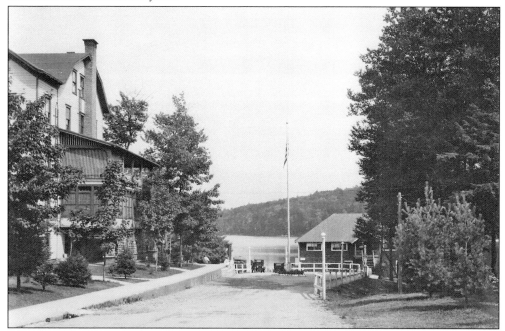

The Glennmore Hotel at the head of Big Moose Lake was built in 1899 for Dwight Bacon Sperry. William R. Rich of Lowville did the construction work for the stately four-story hotel. It was closed for a decade in the 1940s but reopened for the 1950 season by the new owner, Michael D. Conry. Fire destroyed the landmark hotel that September, but area firemen were able to save the cottages on the property.

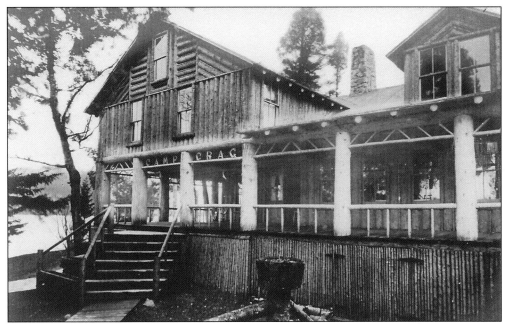

Henry H. Covey opened Camp Crag (above) in the late 1880s and was the proprietor of this well-known Big Moose Lake resort until 1922. He was appointed as the first postmaster of Big Moose in 1893. Henry's son Earl W. Covey spent most of his life in the Big Moose region. He was a guide, a hotel proprietor, and a master builder of many camps and the Big Moose Chapel. Several years after his first wife Addie's death in 1920, Earl married Frances Alden and built Covewood Lodge (below) at Big Moose Lake. The lodge is a fine example of Earl's ability to harmoniously blend native wood and stone. Since 1951, Maj. C. V. Bowes and his family have lovingly cared for the resort. Covewood was placed on the National Register of Historic Places in 2004.

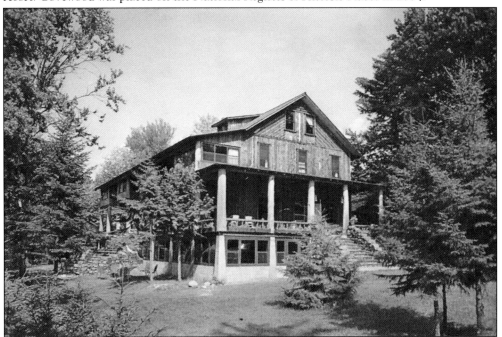

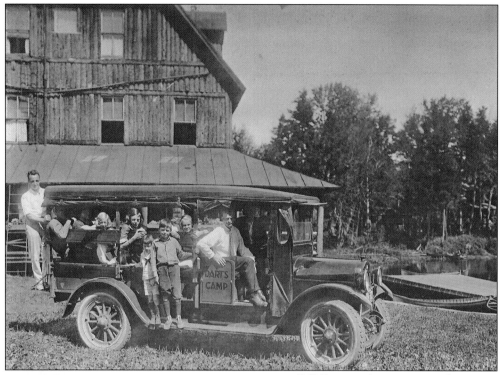

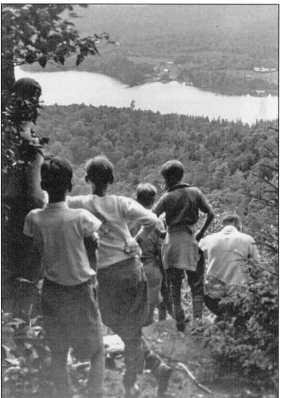

Bill Dart set down roots on the Second Lake of the North Branch in the 1880s and operated a rustic resort there for more than 30 years. Bill Dart's daughter Emma and her husband, John Lesure, established a youth camp at Dart's resort in the 1920s. This photograph was taken in front of their camp in 1922.

George Longstaff became the proprietor after a bank foreclosed on Dart's Camp in 1941. In 1960, Longstaff sold the 1,200-acre resort to the YMCA of Greater Rochester, and it was renamed Camp Gorham. This group of young men found a ledge that provides a bird's-eye view of their camp in the distance on Dart's Lake.

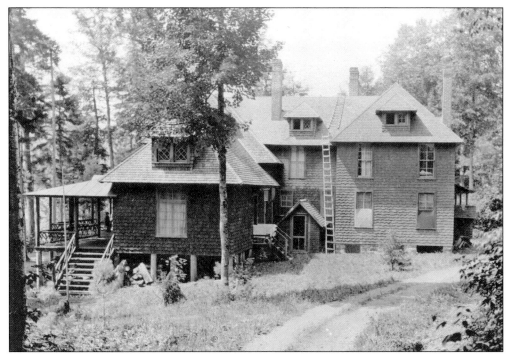

Architect Charles E. Cronk designed this lodge on Cascade Lake, a short distance east of Dart's Lake, a century ago for Charles S. Snyder's summer residence. Snyder was a lawyer and business partner of Dr. William Seward Webb. George Longstaff paid $25,000 for Cascade Lake in 1937 and opened an equestrian youth camp. After the state purchased the entire 556 acres in 1962, all the buildings were torn down.

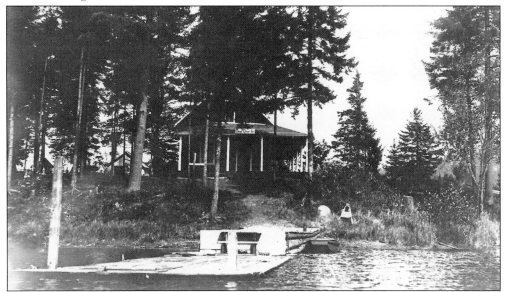

On the canoe carry below Dart's Lake is Rondaxe Lake, formerly called the First Lake on the North Branch. The name Rondaxe was applied by the Thistlethwaite group who purchased the lake and thousands of additional acres from Dr. Webb in 1903. This is Ed Smith's rustic camp, called Dew Drop Inn, in 1912. It was located on a small Rondaxe Lake island.

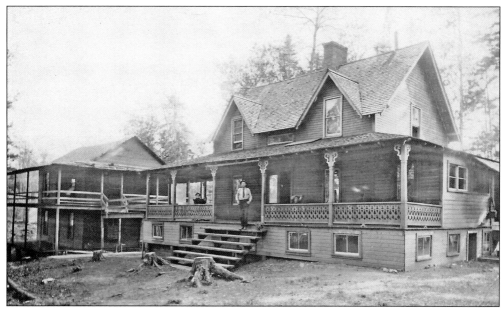

Clearwater was a busy station stop on the Mohawk and Malone Railroad and the transfer point for passengers heading to Fourth Lake on the Raquette Lake Railroad. William S. deCamp built two hotels here in 1897 and established a mill nearby in 1904. In 1912, Clearwater's name was changed to Carter Station. The once bustling community, with the mill, depot, school, and sportsmen's hotels, is now gone in this virtual ghost town.

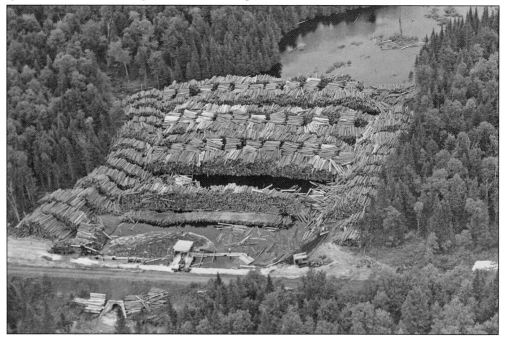

This 15,000-cord pile of pulpwood was cut by Clarence J. Strife's company near Carter Station along the North Branch of the Moose River. This was just part of the softwoods cleared during cleanup operations after the big blowdown in 1950. Utica photographer Dante O. Tranquille took the photograph from a seaplane piloted by Merrill Phoenix.

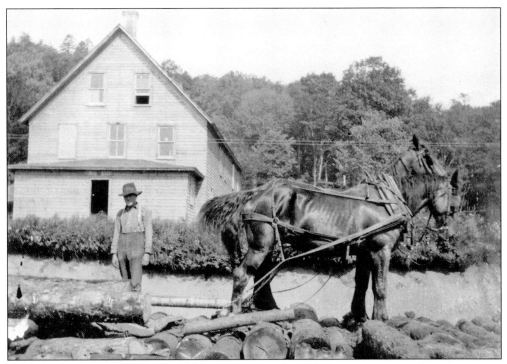

Just before the North Branch of the Moose River reaches Old Forge there is another ghost town, Moulin, once the site of the Herkimer Lumber Company's mill and logging camp shown in this 1904 photograph. In June 1906, Rondaxe Lake cottagers filed suit against the company. The 175,000 logs, boomed on their lake and bound for the mill at Moulin, had caused significant damage to the camp owners' docks, boathouses, and shoreline. Below, on the left, is one-armed Ed Smith, foreman of the mill at Moulin. According to a local legend, Smith's body was found one day under the railroad tracks at Thendara with $4,000 in his pocket. A rubble dam and a few old pilings from the mill are the only remnants today of the Moulin lumber camp and mill.

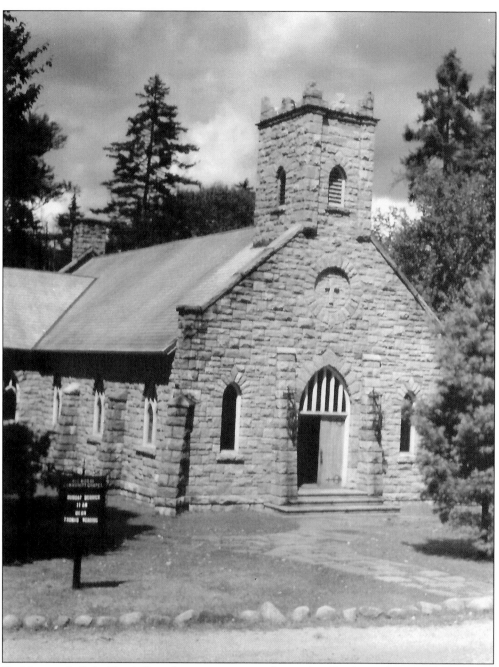

Big Moose, of all the North Branch communities, is alive and well today with several restaurants, lodges, a marina, and scores of well-maintained seasonal camps and year-round homes. Students in the area attend the school in Old Forge. Many of the camps are still owned by descendants of 19th-century property owners. The historic Big Moose Chapel was designed by Earl Covey and dedicated in August 1931. During the summer, the chapel hosts many community events and weddings most every weekend. A traditional fair is held every August. Renowned balsam pillows that helped to raise funds for the construction of the chapel decades ago are still made and sold at the fair each summer.

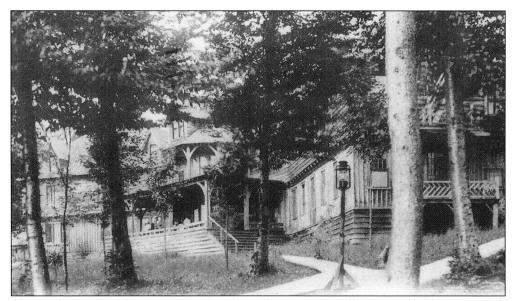

The South Branch of the Moose River flows through 50,000 acres of land owned by the Adirondack League Club. The club was formed in 1890 and remains the largest sportsmen's preserve in the Adirondacks. Construction projects led to permanent year-round employment for Old Forge guides, carpenters, stonemasons, cooks, game protectors, and caretakers. William S. Wicks of Buffalo designed the above clubhouse, completed in 1893, at Little Moose Lake. It was destroyed by fire in April 1913 and replaced by the clubhouse below designed by architect Augustus D. Shepard. It is now called the Summer House. Shepard is best remembered for his rustic arts and crafts style and use of honey-toned peeled spruce logs. The simplicity of his designs that melded into their natural lakeside settings was an inspiration incorporated into many state and national park buildings.

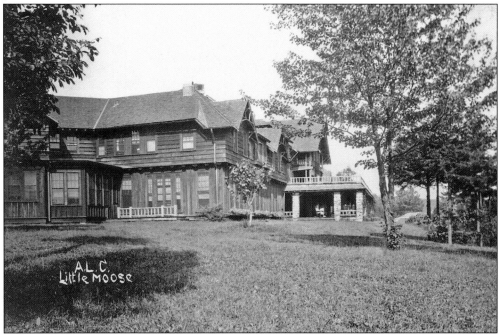

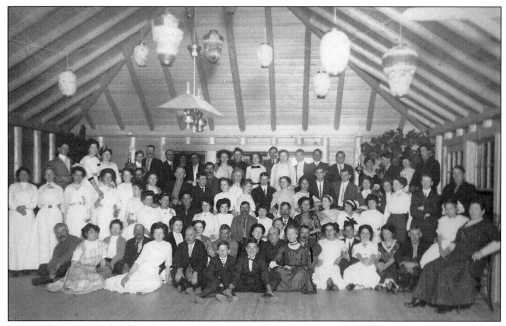

The William S. Wicks's boathouse at Little Moose Lake was torn down in 1912 and replaced with a new one designed by New York City architect Augustus D. Shepard. It houses nearly 50 boats at lake level, while the second story functions as a glorious space for special dinners, movies, and dances, as pictured here.

Augustus D. Shepard was a nephew of William Rutherford Mead of the Gilded Age architectural firm McKim, Mead, and White. Although Shepard designed country estates, churches, and urban residences, he lived and worked at the Adirondack League Club for nearly 40 years. In 1931, he published an anthology of his designs for rustic lodges and boathouses in a book titled *Camps in the Woods*.

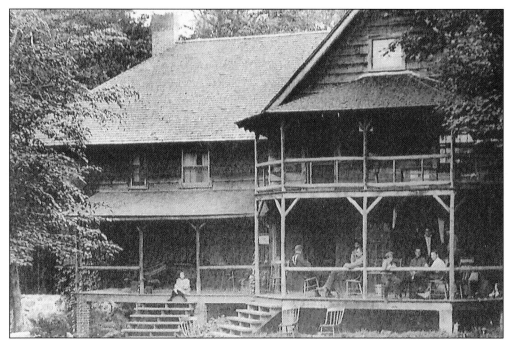

Guides made life in the woods possible and were a valued part of camp staffs. They were provided lodging near the clubhouses or with private households at the club's principal lakes: Little Moose, Bisby, and Honnedaga. This is the Wicks-designed guides' house at Little Moose that accommodated several dozen men. In 1912, Augustus D. Shepard undertook the first of several renovations. Today it serves as the club's Winter House.

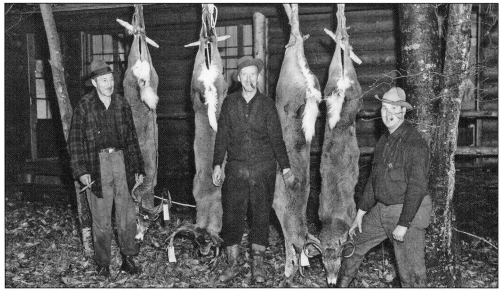

Three Adirondack League Club guides—from left to right, Robert Goodsell, Donald "Red" Perkins, and Perry "Pitt" Smith—are pictured here after a successful day of hunting at the preserve in 1946. Some of the guides, including Robert Goodsell, worked year round as caretakers of private camps at the club. They made repairs to the buildings, chopped wood for the fireplaces, and kept the roofs shoveled in the wintertime for their clients.

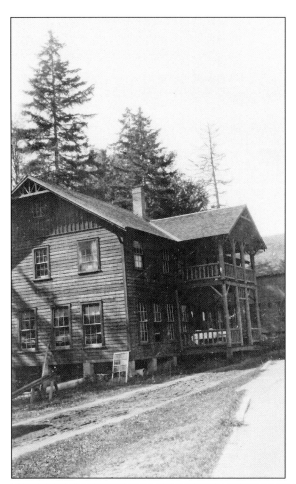

The Bisby Lakes are located 10 miles from Old Forge. The Bisby Club incorporated in 1878, establishing it as one of the first sportsmen's clubs in the state. The Bisby Club merged with the Adirondack League Club in 1893. Tragically, the original Bisby Lodge at left burned to the ground in December 1939. Below, an early launch is moored near the shoreline of remote Honnedaga Lake. Reaching Forest Lodge on Honnedaga Lake required a long drive from Forestport and a boat ride. It is the only Adirondack League Club lake where motorboats are allowed. The historic clubhouse in the background succumbed to fire in 1955.

Six

HISTORIC OLD FORGE
CELEBRATING OUR HERITAGE

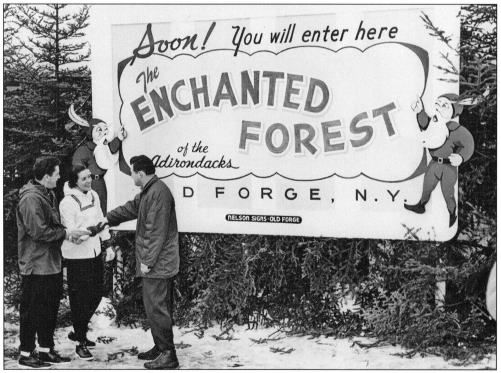

History lives in Old Forge. The Enchanted Forest opened in the summer of 1956 and is known today as the Enchanted Forest/Water Safari. It is one of the few surviving kiddie parks in the Adirondacks and welcomes many third-generation visitors. Manager Joe Uzavinis (right) is shown here greeting the 1956 winter carnival king and queen, Fran Walsh and Lee Ann Meriwether. This chapter presents photographs of Old Forge that, like Enchanted Forest, inspire imagination and nostalgia.

The Old Forge municipal beach has been a center of summer activities since the town expanded bathing facilities in the 1930s by passing a public improvement bond. Whole days were spent with Chief Maurice Dennis, son of Chief Jules Dennis (page 11), who taught several generations of youngsters how to swim. Tennis courts, a waterfront boardwalk, and park benches add to this favorite gathering place in the heart of town.

J. B. Fenton Clark acquired this waterfront property in 1948 and built cabins to suit the vacation needs of postwar auto traveling families. Fenton was the son of Fletcher and Aruma Fenton Clark, former proprietors of the Mayflower Inn and boat livery. Clark's cabins were later converted to Clark's Beach Motel, now owned by Dan Rivet of Old Forge.

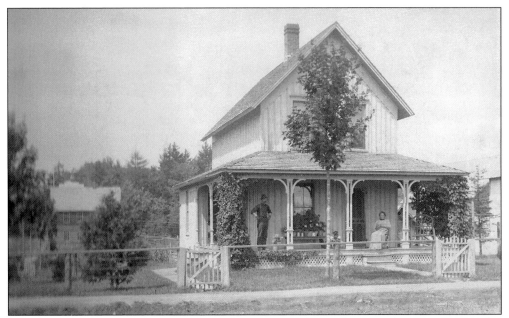

Commodore Theodore Seeber and his wife, Etta, moved into their new home on present-day Codling Street in 1889. Theodore Seeber was a master boatbuilder and became the first fire chief of the community's Rescue Hook and Ladder Company in 1907. This is one of the oldest buildings in Old Forge and is now home to the A. R. O. Adventures rafting company.

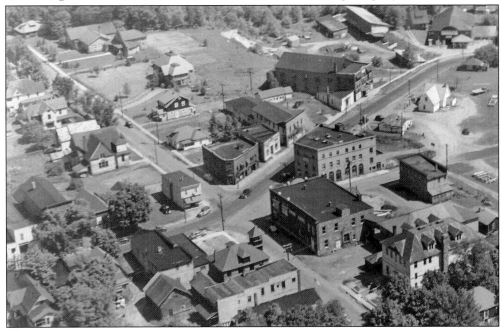

This 1940s aerial view of Old Forge overlooks the Busy Corner. Prominent historic buildings visible today include the Masonic Temple, the Old Forge Hardware, and the Strand Theater. On Crosby Boulevard are the old and new Presbyterian churches, the former Callahan and Marks homes, and the Cohen residence, currently the Old Forge Library. On the right is a ball field where the fire station is today.

Bug-fighting products for sale at the Old Forge Hardware surround A. Richard Cohen, son of Moses Asher Cohen. Controlling black flies is somewhat of an obsession in June in the Adirondacks. By the late 1940s, many towns used DDT that was sprayed from trucks and airplanes. In recent years, Old Forge has pioneered the use of BTI, an organic treatment of larvae in streams.

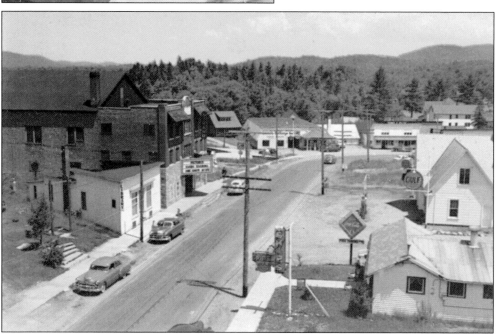

The Old Forge Library was founded in 1914 and was once housed in the small clapboard structure, known today as Sassy Scissors, on the left of this photograph. Next door is Thomson's Strand Theater that opened in 1923. For many years, Bob Card and Helen Zyma have been carefully restoring this historic building.

Harry and Dora Berkowitz acquired this dry goods store in 1907. Harry poses for this photograph with four of his five children—Altha, Anna, Hyman, and toddler Jacob, who was born in 1909. Jacob, a veteran of World War II, was the proprietor of the Maple Diner next door for nearly 50 years. Both of the Berkowitz buildings have been recently rehabilitated.

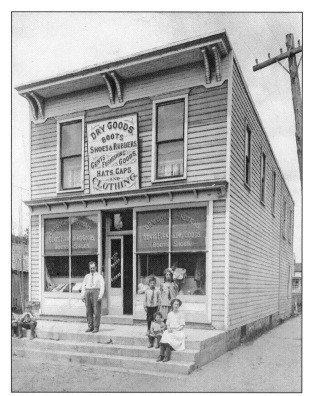

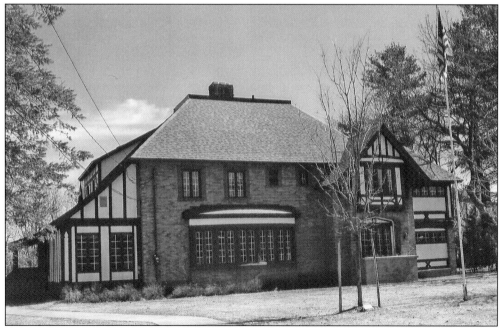

Soon after recouping from the fire that destroyed the Old Forge Hardware in 1922, Moses Cohen built this substantial home on Crosby Boulevard. It was elegantly designed with sun porches and a porte-cochère. In 1977, the family donated the building to the Old Forge Library. It has been enlarged and renovated to meet the needs of a 21st-century library operation.

The First Presbyterian Church on Crosby Boulevard was dedicated in 1897. Prior to that date, Rev. Dr. Samuel J. Niccolls conducted outdoor summer services at his camp on First Lake. The congregation quickly outgrew their small frame church building. Rev. Benjamin Knapp and parishioners Lyon deCamp, Eliza Helmer, and Walter Marks took part in the 1917 ground-breaking ceremony above for a new church farther down the street. Below is the new stucco Spanish-style building that has since been remodeled and enlarged. The First Presbyterian Church was renamed Niccolls Memorial Church to honor the beloved summer pastor from St. Louis.

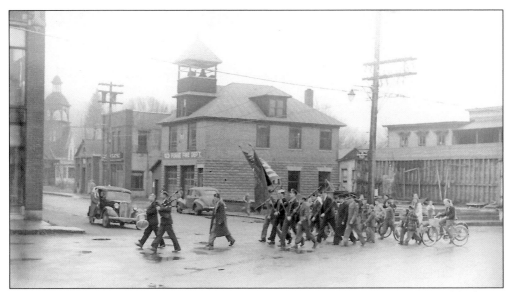

American Legion members are marching past the ruins of the Covey Block, destroyed by fire in 1942. Old Forge firefighters responded from their station house with the bell tower next door. The library, historical society, American Legion, and town lockup all shared the fire station building at various times. George Goodsell completed it in 1912. Nathan's bakery now occupies this historic Crosby Boulevard location.

Veterans of the 1907 Rescue Hook and Ladder Company are laying the cornerstone in 1949 for the new fire station at the corner of Lamberton and Fulton Streets. From left to right are Walter Marks, Tom Wallace, Ben Sperry, and Jacob Kline. Old Forge firefighters proudly celebrated the 100th anniversary of their volunteer service to the community in 2007.

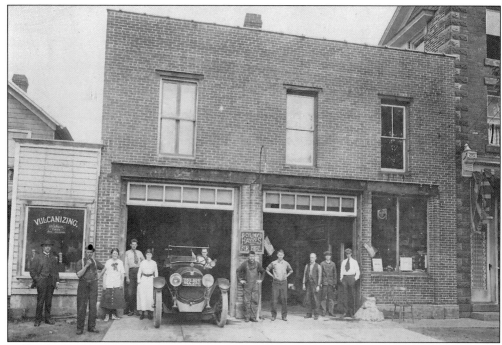

William H. Young was the original proprietor of this garage on Main Street next to the Lenhardt Bakery before he moved to Remsen in 1918. Lyman Appleton and G. Ferris Williams operated the business until 1929. It has since been the location of the Helmer Fuel Company. Leonard Helmer, a World War II veteran who also served as town supervisor for 10 years, founded the enterprise.

George G. MacFeggan Jr. opened The Ferns Restaurant in 1924, taking its name from the greenery that filled the flower boxes. The restaurant seated 30 patrons. In 1931, he moved the building across the street. The Ferns was expanded and accommodated 300 diners in its heyday. A 1948 menu offered a "dry martini with dinner for an additional 35¢." Today the building houses the popular Walt's Diner.

This Main Street hotel, built by Adam Tennis in 1898, has had many owners. Here, in the 1940s, it was called Hotel Cleaver when owned by Fred Cleaver of Boonville. Thomas Pinto was the proprietor in 1961 when a serious fire nearly destroyed the building. It has undergone substantial renovations in recent years for retail businesses.

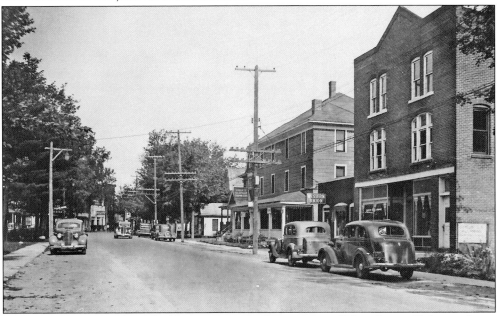

The 1902 Glenn Block brick building anchors this historic part of Main Street. Today it is home to a retail furniture emporium known as Wilderness Interiors. Beyond the Western Union office is the former Doolan's Forest House. Herron Realty offices are located in this well-maintained former boardinghouse that still has its welcoming open veranda.

Jacob and Anna "Nannie" Kline's house appears much the same as it did when it was built in 1898. Jacob was a master stonemason whose work is visible under many Main Street buildings today. The Klines are remembered for walking hand in hand on Sundays to the Busy Corner. Jacob, a devout Catholic, headed right to St. Bartholomew's, and Anna turned left to attend services at Niccolls Church.

George and Elizabeth Deis came to Old Forge in the 1880s to establish a sawmill in the old Brown's Tract mill building by the dam. They raised six children in this Main Street home, which was restored several years ago. The Deis Mill relocated to Fulton Chain near the depot in 1900 and provided building materials for most of the vintage homes and camps in the area.

Eliza Helmer opened the new Moose Head Hotel in 1922. She exchanged the 24-room hotel in June 1923 for Pearl Hoffman's 15-room boardinghouse down the street. This photograph was taken in the 1940s, when the Harry Kellogg family, former proprietors of the Glennmore Hotel, revitalized the business. It was later converted to a hardware and lumber business operated by the Foley family for many years.

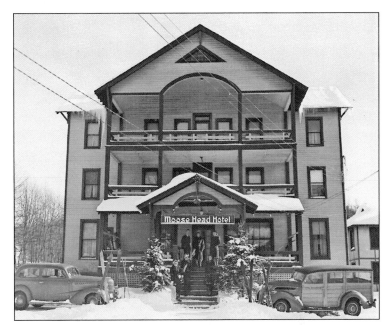

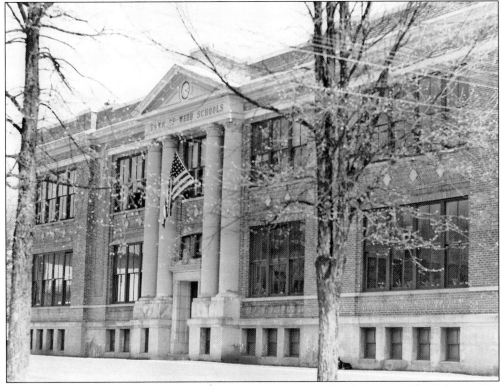

This section of the school building in Old Forge was completed in 1914. All of the smaller schoolhouses in the district were closed by the 1940s. Students in the Town of Webb School District come from all over northern Herkimer County to attend this school. Buses also transport students from parts of Hamilton and Oneida Counties. A snow day is rare for the approximately 360 students who currently attend grades K–12.

Adams Street was named for Victor Adams of Little Falls, who was a partner in Samuel Garmon and Dr. Alexander Crosby's Old Forge Realty Company. Among the first to buy a lot on Adams Street in 1895 was Adirondack guide Archibald Wellington Weedmark. Archibald and his bride, Mary Ellen MacDougall, came to Old Forge in 1891 and obtained work "winter sitting" Rev. Dr. Samuel Niccolls's camp on First Lake. The Weedmark residence above is one of the few homes in Old Forge still owned by descendants of the original builder. Guide Alvin Wood built his Victorian home below next to the Weedmarks' home. Alvin and his wife, Emma, worked for Bisby camp owner J. F. Talcott. They spent 11 years in New Jersey, where Alvin was the superintendent of Talcott's private estate. In 1938, Alvin died in his Adams Street home, which still stands today.

Several neighborhoods in Old Forge have fine examples of "mail-order" houses that were built during the 1920s and 1930s. Building materials were often shipped by railcar. This charming five-room bungalow remains virtually unchanged since Jack Hughes built it for his family in 1930. It was the Sears-Roebuck Collingwood Model 3820 and cost $1,497. The model number is still visible on the floor joists and attic rafters.

Phil Christy was the patriarch of a large Old Forge family and a well-known guide. The Christy homestead on Main Street was built on a lot purchased from Garmon and Crosby in 1897. On the porch are, from left to right, son-in-law George Villiere, Phil Christy, daughters Lelia and Julia Christy Villiere, wife Bridget, and daughter Anna. Among the youngsters are Reggie and Clarence Villiere, Donald Christy, and two Isenecker neighborhood children.

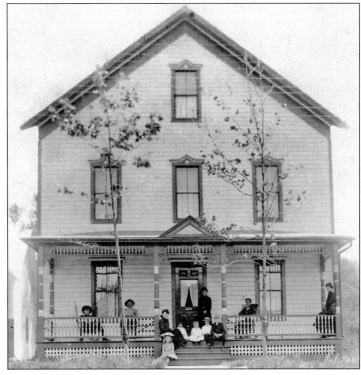

Louella Garmon and her husband, Percy Howard Powell, are shown in this photograph with her mother, Jennie Garmon, in front of their family home. Louella's father, Samuel Garmon, and his partner, Dr. Alexander Crosby, purchased the Forge House in 1888 and sold building lots to most of the community's pioneer settlers. Louella died in 1965 at the stately homestead still standing on Park Avenue.

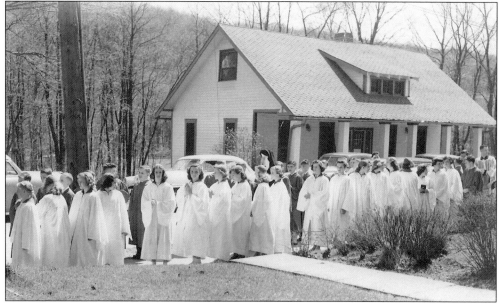

A confirmation class lines up on Park Avenue en route to St. Bartholomew's Church. The present owners of the Aladdin mail-order house in the background have the 1922 blueprints for the building. It lies along the route of the former 2-mile railroad spur to the Old Forge waterfront. John S. Cameron operated a Graffenburg Dairy distribution business here in the 1940s.

Town of Webb voters approved a bond issue in the late 1950s to purchase McCauley Mountain for a new ski center. The construction firm of Ehrensbeck and Morin completed the access road and parking lot off of Bisby Road. Hall Lift, Inc., installed this T-bar that had a capacity of 1,100 skiers per hour. The 50th anniversary of the ski center was celebrated in 2009.

John "Louie" Ehrensbeck and Hank Kashiwa Jr. began their skiing careers on Maple Ridge before the McCauley Mountain Ski Center opened. Both went on to represent Old Forge as members of the U.S. Olympic Ski Team. Ehrensbeck (right) qualified for the biathlon and cross-country relay teams in Grenoble, France, in 1968. Kashiwa raced with the alpine team in Sapporo, Japan, in 1972. (Courtesy of Ed Diamond.)

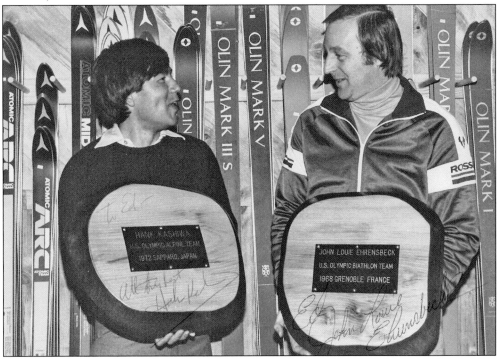

The tradition of crowning a king and queen during Old Forge's winter carnival began in 1946. Two Uticans, Katherine Hoover and Roger Kenyon, received the honors, according to publicity director Joseph Grady, because "they were typical of out-of-town guests." Newlyweds Gerhard and Lou Schwedes, shown at left, served as the 1960 king and queen. Schwedes was a running back and captain of the 1959 Syracuse National Championship football team. Pictured below is an early-model snowmobile, a Sno' Jet, in front of the 1960 ice castle. Winter carnivals are still held in Old Forge during February, although they are not the weeklong affairs of the past. The festival includes the coronation of the king and queen in front of an ice castle at McCauley Mountain Ski Center as well as ski races, dancing, great food, and a brilliant nighttime fireworks display.

Nelson Dunn of Big Moose was awarded the contract to build an A-frame chalet at the ski center in 1960. It was enlarged in 1986 and hosts weddings and community events throughout the year. Since 1959, when the first single chairlift was installed, summer visitors like this group are able to ride to the summit and enjoy the panoramic views over the Fulton Chain of Lakes.

J. Armand Bombadier of Canada is credited with developing the first modern-day recreational snowmobile in the late 1950s. Snowmobiling quickly gained popularity and has boosted the winter economy at Old Forge since the 1960s. Snodeo weekend, held in early December, kicks off the season and brings all the top snowmobile manufacturers to town. The Old Forge area offers riders more than 500 miles of well-groomed interconnecting trails.

A. R. O. Adventures' buses, in winter storage at Thendara, await the rushing springtime rapids of area rivers. The late John Caruso took this stunning photograph above. Adirondack guide and A. R. O. owner Gary Staab pioneered white-water rafting trips down the Moose River 30 years ago. Enthusiastic customers come every April to experience the most unpredictable and wildest rafting trips in the Northeast. According to Gary (the man with the beard at the back of the raft), "You only have to do the river once to find out why the Moose is referred to as Slam-Dancing with Mother Nature."

Rev. John Fitzgerald, beloved pastor of St. Bartholomew's Church, came from Ireland and had no known relatives in the United States. He appealed to real estate developer William Thistlethwaite (right) that it was time for the town to have a cemetery and a place to bury his bones. In 1921, Stephen Bazyliv was the first person to be buried in the new cemetery on land donated by Thistlethwaite. Bazyliv was a Ukrainian immigrant who came to Old Forge for his health after serving in World War I. The entire community escorted his body to the cemetery. The large cross in the photograph below shows Thistlethwaite's burial place at Riverview Cemetery. At the foot of his grave is a marker for the bones of Father Fitzgerald, who died in Old Forge in 1924.

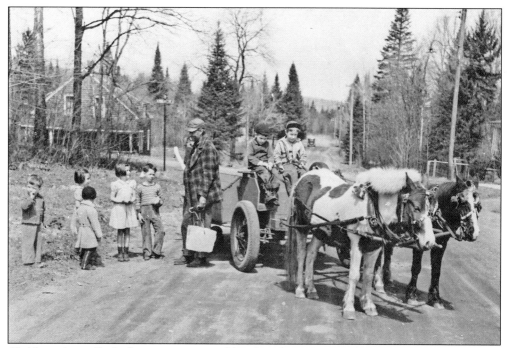

Children always flocked to see iceman and local pied piper Ernie Flanders, shown here making deliveries on North Street. Flanders came to Old Forge in the 1920s to help build the Strand Theater. He lived contentedly with his cat "pretty-kitty" in a two-room shack and cooked over a woodstove. Residents held an Ernie Flanders Day in May 1990 to show appreciation for his contributions to the community.

These artifacts from the 1799 John Brown mill were discovered below the dam in the river by town workers. They have been displayed in several locations through the years. In 2009, the treasured artifacts were permanently installed as the centerpiece of the new Point Park at the Busy Corner.

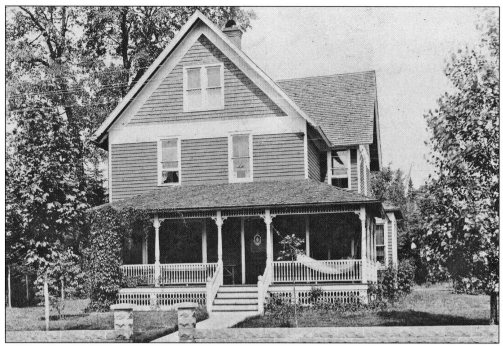

George Goodsell built this family home on Main Street in 1899. He operated a stagecoach business through the wilderness to the Old Forge region before the railroad arrived in 1892. From 1902 until his death in 1924, he was the principal contractor for architect Augustus D. Shepard, who designed most of the prestigious Adirondack League Club retreats during this period. Robert "McGee" Goodsell worked with his father and is shown on a construction site in the photograph below. He was a veteran of World War I, an Adirondack guide, and a camp caretaker. Robert died at age 100 in August 1994. Proud of the Goodsell family's role in the development of Old Forge, Robert generously willed the family home to the Town of Webb Historical Association.

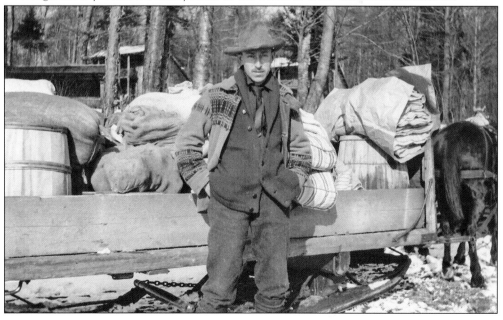

Bernard Hemmer came to Old Forge for his health following World War I. He worked as an artist and built a cottage colony on Park Avenue behind the school across from the Maple Ridge ski area. The school purchased the cottages to expand the campus. The last Hemmer cottage (shown above at its original location) on the site was sold to a preservation group in 2001. After a year of fund-raising, it was moved down Park Avenue, as seen below, to a new waterfront home on a lot donated to the historical association. The grassroots effort to save Hemmer Cottage involved supporters far beyond the Fulton Chain who appreciated the local effort to save a historic building and preserve its unique Adirondack architecture. Heritage tourism continues to grow in the Old Forge area.

The George Goodsell homestead is the headquarters of the Town of Webb Historical Association. The association is dedicated to preserving and sharing the history of the region. The property, including an icehouse and carriage barn, has been placed on the National Register of Historic Places. Careful restoration has preserved the vintage interior while allowing the building to function as a museum. It is open to the public throughout the year and is located at the corner of Gilbert and Main Streets, across from the post office.

Discover Thousands of Local History Books
Featuring Millions of Vintage Images

Arcadia Publishing, the leading local history publisher in the United States, is committed to making history accessible and meaningful through publishing books that celebrate and preserve the heritage of America's people and places.

Find more books like this at
www.arcadiapublishing.com

Search for your hometown history, your old stomping grounds, and even your favorite sports team.

Consistent with our mission to preserve history on a local level, this book was printed in South Carolina on American-made paper and manufactured entirely in the United States. Products carrying the accredited Forest Stewardship Council (FSC) label are printed on 100 percent FSC-certified paper.

MADE IN THE USA